Seeing the Light

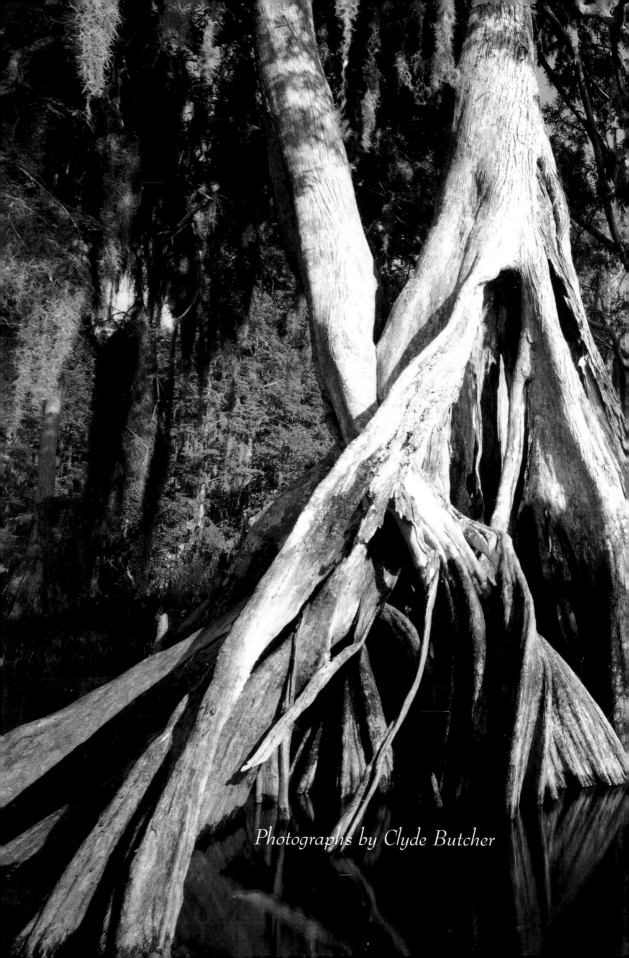

Photographs by Clyde Butcher

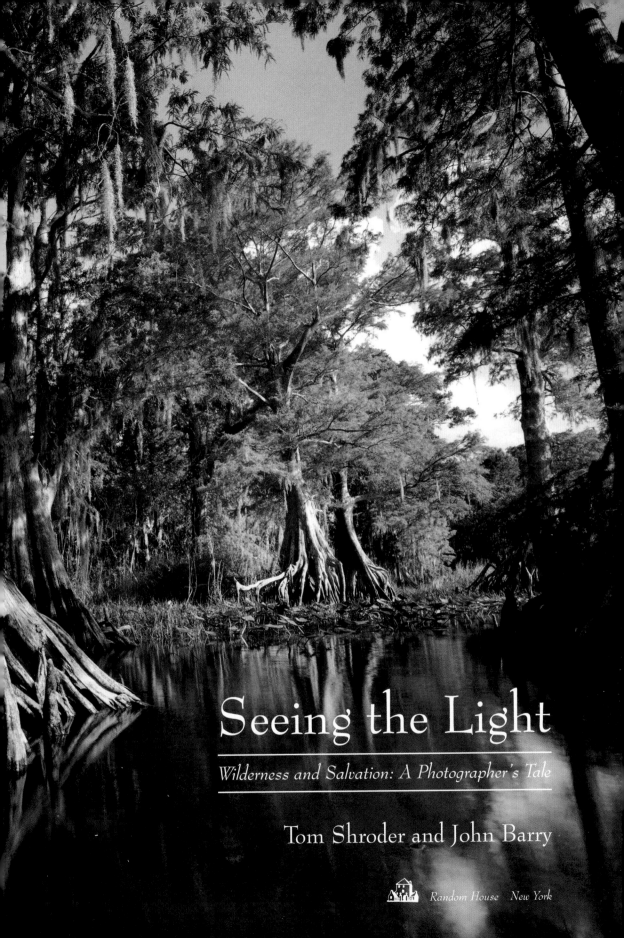

Seeing the Light

Wilderness and Salvation: A Photographer's Tale

Tom Shroder and John Barry

Random House New York

All photographs by Clyde Butcher. Used by permission.

Library of Congress Cataloging-in-Publication Data
Shroder, Tom.
 Seeing the light: wilderness and salvation: a photographer's tale/
Tom Shroder and John Barry.
 p. cm.
 ISBN 0-679-43282-5
 1. Landscape photography—Florida—Everglades. 2. Butcher, Clyde, 1941–
3. Everglades (Fla.)—Pictorial works. I. Barry, John. II. Title.
TR660.5.S57 1995 770'.92—dc20 95-9678
[B]

Manufactured in Italy
2 4 6 8 9 7 5 3
Book design by Tanya M. Pérez
First Edition

This book is dedicated to Ted Butcher,
and all other innocent victims of human carelessness

Acknowledgments

Seeing the Light was possible only because of the openness, generosity, and trust of Clyde and Niki Butcher, who allowed us into their lives and showed us their remarkable world. A great many others were nearly as indispensable: Jackie Butcher, Oscar Thompson, Laberta Thompson, Totch Brown, Ron Jones, Suzan Ponzoli, Henehayo and Cassandra Osceola, Hokie Lightfoot, Cesar Becerra, and John Kalafarski chief among them. Al Hart had the vision to see something special in this story, and Robert Loomis had the wisdom to help us shape it. We also want to thank Lisa Shroder for helping to keep us on track, *The Miami Herald* for printing the magazine story that got us started, and David von Drehle, for supplying the phrase "Pittsburgh plutocrat."

Contents

List of Photographs

Seeing the Light

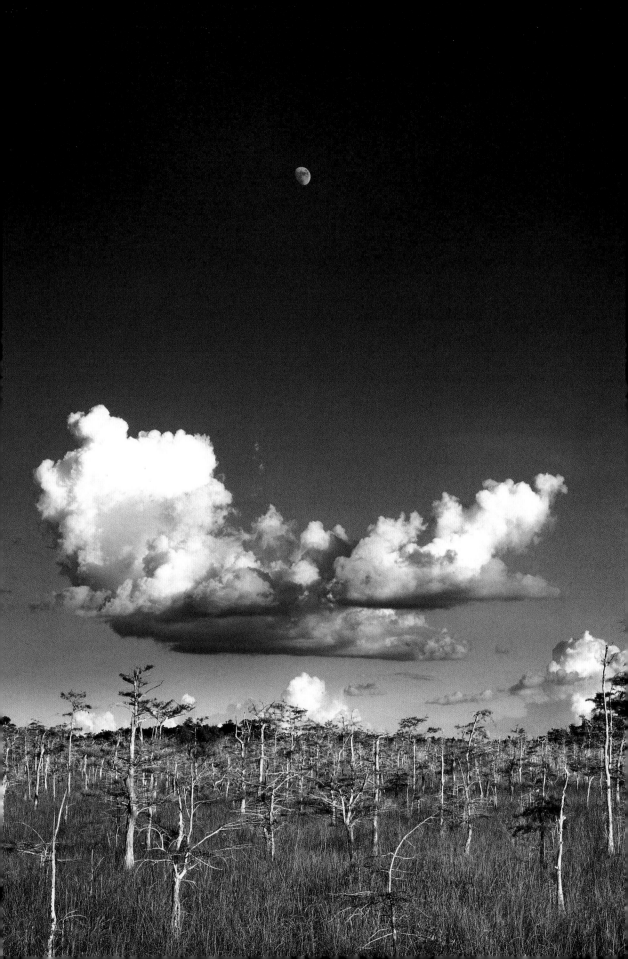

1. Shooting the Moon

The photographer squatted with his camera in the muddy white Everglades marl, large and dirty as a bear, waiting for the moon to rise. Mists of warm rain from passing thunderheads mingled with his sweat, matting spools of unwashed hair jutting from under his straw hat. The dampness reduced his shirt and pants to rags with a few buttons, exposing patches of ruddy skin inflamed by dozens of saw grass cuts. He was oblivious to it all, unconsciously fingering his wild gray beard, lost in contemplation beside his wooden box camera. Like him, the camera looked vaguely ancient but durable, from some remote moment, an optic machine whose like had immortalized stiff-backed generals of the Civil War. He matched its square shape, his broad torso joined to legs as thick as cypress trunks and feet as wide as skiffs.

Clyde Butcher knew that what he had become, a man with a camera waiting in the wilderness, was what he always had been

meant to be, what his whole life had been building toward. But his destiny held no pleasure for him. Loss had brought him here, reduced to his essential condition.

He had left home that morning, knowing his destination, this spot marked days before, everything planned and ready except for the proper celestial alignment. As on all the other days of these black months, he had stowed his eight-by-ten-inch camera, his crates of black-and-white film, his trunk of polished lenses, and driven away in his truck, disappearing himself down a rutted grade left by oil drillers, until the dwarf-cypress prairie swallowed him in a circumference of wild nothingness.

Here was what he craved, a place where time floated by in a procession of clouds. They sailed past, misty galleons, one by one. Clyde paid less attention to their slow poetry than to their composition and texture, the delicate play of shadow and light, translating it all into mathematical shorthand: fractions of seconds of shutter speed, minute variations of f-stop. Numbers buzzed through his head, tranquilizing him. Clyde relaxed, immersed himself in this ocean of light, let its streams and currents sooth him as he watched far above the ships under billowing sail. The grass, swept into waves by the wind, made a sighing, undulating sound, cut by the surprising, plaintive cry of an osprey, which grew and faded as the bird swooped low, then away. When the osprey was gone, vanished to a vibrating point of energy, the wind sound was still there, both near and distant, pure as the light, vast as the sky, minute as the flash of blue rippling on the wings of the dragonflies settling on the sawgrass at his hip.

What a conceit, to attempt to convey this beauty, capture it in shades of gray on a piece of cut paper. But Clyde had a vision, and he calculated how to achieve it. If the vapor convoys held, if the sun behind him stayed clear, the cypress would illuminate as though inwardly aglow and leap from the muted tones of the prairie just as

the moon rose. Then Clyde would climb a ten-foot stepladder to his elevated wooden box, tottering improbably above the swamp, and make his picture.

In late afternoon, a pale moon rose, gibbous and translucent. When it had climbed two hands above the horizon, a great cloud, majestically symmetrical with a rising curve fore and aft, floated into his viewfinder, directly below his fragile moon. He mounted the stepladder, angling over the cypress, and buried his head under his black cowl. Then he fired. Nothing. The shutter didn't flinch. It was old, manufactured in the sixties, sandwiched between two elements of the lens, susceptible to corrosion in these swamp waters. Frantically, in the waning sunlight, he unscrewed the lens, stuck his heavy fingers into the aperture, and forced the metal leaves of the shutter, jamming them open. He ducked back under the cowl. The cloud, the moon, the sunlight illuminating the cypress—all the elements held their places. He reattached the lens, blocked its stare with a black photographic plate, and loaded live film. Then he lifted the plate, guessed an exposure, trying to calculate in his head the passage of a quarter second before bringing the plate back down. He yanked out the film, reloaded. He made fourteen exposures with this crude method, thirteen of them ruined, and one that would emerge in his darkroom, a catalog of the details of perfection.

As his hands moved automatically, he lost himself in the process, his mind absorbed by the single, uncomplicated task, loss and hatred obliterated, rage quenched, fear drowned in this vast, feral oblivion.

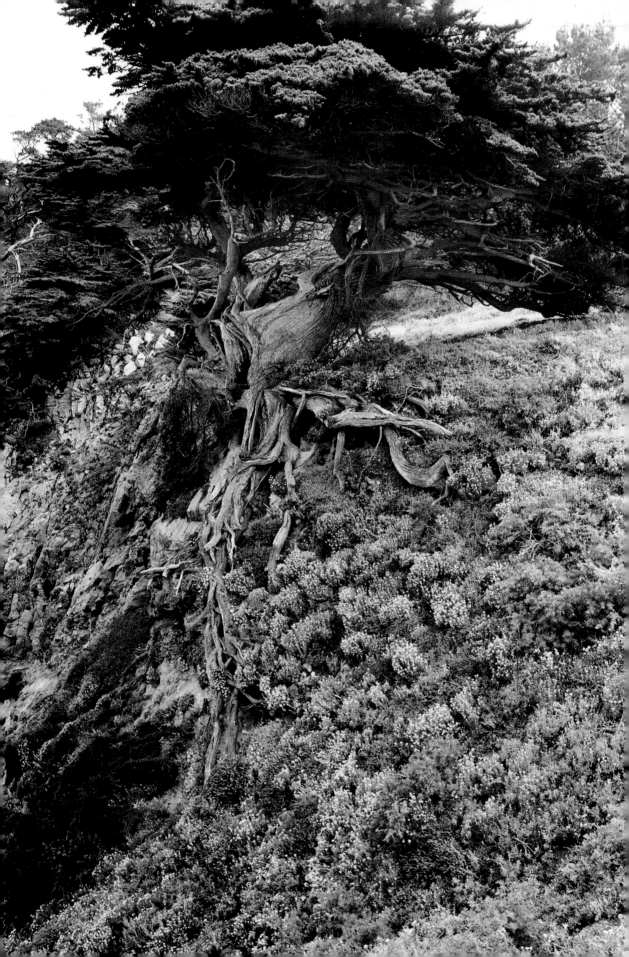

2. *California Roots*

Only weeks earlier, in the fall of 1986, the bulky carton arrived from New York. Clyde unwrapped the package with slow pleasure, intoxicated by the scent of teak. The scent rose from the box, pungent and distinctive, something like that of cedar, and Clyde tried to imagine the tree from which the big frame of his new camera had been cut. The tree had been a hundred feet high, with thick, tear-shaped leaves each a foot wide, and small white petals, and it had towered skyward in the Thai rain forest until a swarm of sweating men with chain saws had brought it down. Later, the first savage rip of the sawmill drew its reservoir of resins up through the fine grains so that its raw planks beamed gloriously, even under the dust. Clyde drew his hands across the finish, feeling the teak's texture, luxuriant, yielding. This was not just a camera; it had a soul.

Even so, the possibility that the photographs Clyde made with this simple box would become celebrated—framed and hung in

museums and on the private walls of governors, cabinet members, literary lights—never occurred to him. Cameras like this filled only a humble niche in contemporary art. Large-format photography, in black-and-white, no less, did not make photographers rich or famous. Clyde only wanted the camera to take the photographs he knew he needed to take. He had no thought of becoming an icon, renowned for an ability to render the invisible visible, to make people see what they might be losing before it was too late. He never intended to become anything but himself, a goal he pursued with rare intensity, past sharp turns, smack through dead ends and over precipices. This was not a choice he made, but a compulsion forged somewhere between joy and dread and achieved only after a season in hell.

Before long, this eight-by-ten-inch camera would look like it had been there, too. The brand name, stamped on a small metal plate, IMPERIAL, would become worn, barely readable. With its black bellows retracted and lens removed, the camera would look like just any old wooden box, perhaps a discarded piece of hunting equipment, too battered for anyone to bother carrying out of the woods.

As it weathered, Clyde would not lose affection for it. The box's clean aroma and luster of tropical resins would never be more than a good buffing away from the surface, but Clyde would let the camera age gracefully, let the thin coat of varnish peel and yellow, allow the fine, smooth grains to pock and scar, even let its gleaming brass slides and knobs turn pale green and wobbly.

Clyde would one day own other large-format cameras, more expensive and mechanically superior to his wooden box—one, an eight-by-ten-inch black steel machine with chrome slides that shifted and locked into place with an authoritative click; another, a twelve-by-twenty-inch optic masterpiece of mahogany, worthy of museum display. But he would never completely trust the better

cameras, just as he distrusted anything that was modern and supposed to work perfectly. He had a passion for old things, for things with a history and a promise of perpetuity. He loved machines that had to be manipulated by human hands, that had to be yanked and tugged, swatted and sometimes cursed at, but lasted. Some things endured. Some things, in the grasp of a man's hand, didn't fall to pieces, didn't run haywire. That was his reassurance. The old camera helped calm the visceral dread that had driven him into the swamp, a fear of destruction by human inventions and intentions gone out of control.

Clyde had first encountered that fear earlier than most, running smack into it on a Kansas summer day in 1953. He was only nine years old. He'd had a transient childhood, moving through a series of trailer parks in the Midwest as his father, a metalworker, followed a trail of government contracts from one nuclear-weapons plant to the next. Clyde was only dimly aware of the Cold War, and the race to build more and bigger bombs that put bread on his table. He knew his father's work was hard and dangerous, but it hadn't seemed sinister as well until that summer afternoon in the Kansas countryside. Wandering farther than usual in the woods near his trailer, he stumbled on a towering fence topped with coils of razor wire. Beyond it, Clyde recognized the mass of steel and cement emerging from an ugly scar in the earth as the place his father worked. This was the fence his father passed through each day. On it was a metal sign that bluntly pronounced, TRESPASSERS WILL BE SHOT.

The deadly seriousness of that warning struck Clyde sharply, stayed with him through the coming years of adolescence and youth. Like many of his generation, he keenly felt the burden of living in a time when universal death could rain from the skies without a moment's notice. But for Clyde, the abstraction of nuclear terror was made concrete by that sign on the fence and all it implied. To him, the

possibility of apocalypse was as real as the shoes on his feet and the roof above his head.

Clyde Sr. did not have to consider the end results of his labor to fear for the future. The work itself could be fatal enough. The inherent dangers of heavy-equipment operation coupled with the possibility of accidental radiation exposure would be daunting under any circumstances. In the secrecy and haste of the arms race, scores of workers died on the job, and an uncounted number succumbed much later. It was enough to impress on Clyde Sr.—and on Edna and their only son—that life was short, and risks justified.

Clyde was a small child, shy around people, but he had an inborn boldness that his parents amply nourished. He had few limits imposed on his curiosity, was allowed to roam the woods from an early age, shooting quail and stalking coyote. He grew into a competent young woodsman, able to track and bring down prey with bow and arrow.

Like other small boys, Clyde imitated the tinkerings of his father. He discovered a pleasure in making things. Landlocked Clyde, who had never seen an ocean, was sea-struck for reasons he couldn't explain. He drew boat designs the way other children drew homes with trees and flowers. As he got older, he matched building skills learned from his father to the seagoing images in his mind, crafting boat prototypes from scrap sheet metal salvaged from the nuclear plants.

Clyde's flourishing confidence and curiosity left no room for the concept of failure. Mistakes, his parents taught him, were life's lessons, accepted without regret. Dreams took priority, tedious chores shrugged off. His mother whisked away towels he left on floors; she collected the muddy boots he shed in doorways; she served his plate full. Clyde's only job was to grow.

That half-wild, supremely self-assured, faintly haunted little boy was very much present in the young man Niki Vogel brought home

to her parents in 1962. The Vogels were primed to love Clyde. The way they saw it, Niki at last had bagged "college material," a student of architecture, someone going places, and that was an achievement both parents had desperately hoped for but nearly despaired over.

George Vogel was an accountant, an exacting, cautious intellectual who expected his meals ready and quiet children doing their studies when he came home. He had once aspired to be a cartoonist and spent a summer in the Missouri woods attempting his own Walden experience. But after combat in the Philippines during World War II, he returned home, wistful dreaming replaced by sober focus. He found a mate well-suited. Betty Vogel relished order and activism. They wanted children like themselves: purposeful, ambitious, careful not to squander chances.

What they got in their daughter was a dreamer. From the time Niki reached adolescence, she had spent hours in her room sprawled on her bed, lost in romantic novels. The life her parents hoped for her seemed bleak and dull. She let her blond hair grow long and wore black. She fantasized a tragic bohemian end. The Vogels nervously anticipated an eccentric spinsterhood for Niki, or a short, sad marriage to some spouter of coffeehouse verse.

But with Clyde, for the first time she was bringing home to Palo Alto a serious prospect, an architecture student from California Polytechnic University. Their daughter's rebelliousness, perhaps, had withered under a surge of genetics-induced good sense.

Clyde came calling on a clanking Honda Dream motorcycle, dusty and hairy, leaving rooms he plodded through looking like a Salvation Army shelter. Niki's father came home to find Clyde's boots blocking his path in the foyer. No one had ever left boots in his foyer. The gentleman caller was upstairs in the shower. When Clyde emerged, padding down the hallway—broad backside barely covered by a towel—he left a trail of soapy water on their spotless floor. No one had ever done that, either. "I'd like these boots removed," the

exasperated father called up the stairs. The sentence contained the embryo of what he really wanted: the boots removed, and the boy with them, then a daughter remade to bring home men in cardigans who spoke respectfully and, who knows, maybe even reflectively puffed a pipe.

But the meaning was lost on this one, oblivious to the unwritten rituals of winning parents over. At restaurants, Niki's father made tactful feints toward the check, expecting Clyde to stop him, to insist on paying like a proper suitor, but Clyde sat quietly, insouciant and belly full, like a serene Buddha. And when Clyde spoke of his future, he scoffed at the suggestion of a paper-shuffling architectural apprenticeship. He talked grandly of plunging into his own business, making three-dimensional architectural models and photographing them, a technique he had mastered at Cal Poly to compensate for his inability to draw.

Niki's parents dismissed him as hopeless. Of course, their disapproval only intensified her infatuation. But she was drawn to Clyde by something more elemental: their mutual appreciation for nature. He had no use for the theater or ballet or any of the arts she'd grown up with—he favored peanut butter over foie gras—but he loved the outdoors and filled their courtship with motorcycle trips through coastal canyons and camp-outs in Yosemite. They considered it a badge of honor, proof of their enchantment, when a bear, oblivious to them both, lumbered across their sleeping bags one dark night beneath the tall peaks. Picnic lunches on beaches and hikes down trails through the redwoods left long interludes for talk, and Clyde shared his dreams. He talked about starting his business, about sailing around the world, about making new things.

"I've invented a closet," he told her.

"Oh, really." She laughed. "A closet. I'm afraid someone beat you to it."

"But this is no ordinary closet," he said. "It's for sloppy people like me, who don't pick up their dirty clothes. You just push a button and the floor opens and your laundry disappears."

It was no joke. Clyde showed her the drawings: Every nut and bolt and spring was accounted for.

Niki fell more deeply in love. Clyde was funny, charming, astonishing. But more important, he was open. He was the first male who ever included her in equal conversation, who actually listened to her opinions. When Clyde proposed, her Methodist pastor counseled Niki to wait. They had dated only a year. She was just eighteen, and Clyde only twenty, too young, he warned, to know what they wanted. Beneath the surface was the intimation that marriage to the son of a construction worker would be a step down. But Niki waved off the minister's arguments; she had doubts of another kind. She worried that marriage would change them both, make them conven-

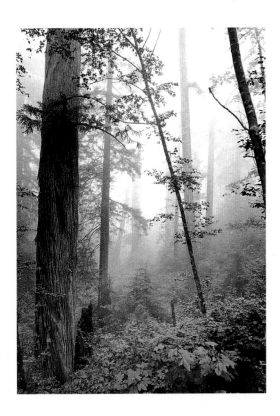

tional. "I don't want to get married," she told Clyde. "I don't want to lead a boring life like I see all around me, all these people who are married, working nine to five. There's no joy in their lives. They're in a rut. I'm afraid marriage would lead to that." Clyde laughed it off. "Ours will be different," he promised.

If she could have grasped exactly *how* different their marriage would be, she'd have been aghast. She first glimpsed the future on their honeymoon. After a traditional church wedding orchestrated by her parents, they flew to Catalina Island on a seaplane. It was the first time Clyde had ever flown. When the engines revved, and the little plane plowed through the water, burrowing under a tidal wave of spray, Clyde thought it might be the last time. Once they landed safely, Clyde rented a fourteen-foot skiff and took his wife into the ocean. This was no calm littoral; the water was jet-black and white-capped, two hundred feet deep just yards from shore. They saw shark fins gliding through heavy swells. While Clyde reveled in the experience, Niki lurched between panic, nausea, and the premonition that marriage with Clyde would be about hanging on for dear life.

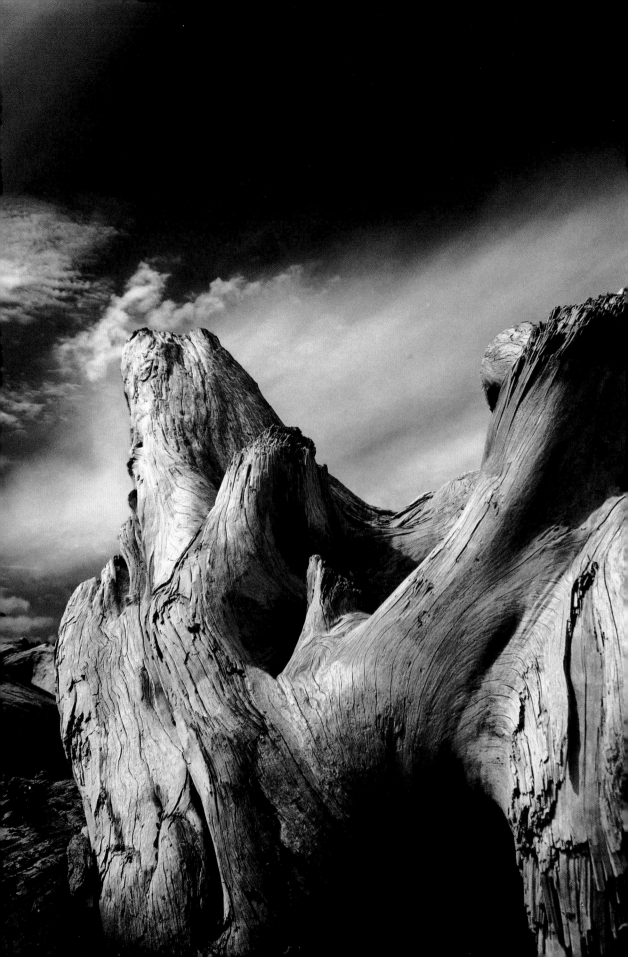

3. Going for Broke

Clyde and Niki began their marriage colorfully, in a ramshackle seven-bedroom hacienda they'd discovered on eighty acres in the hills near La Honda, southwest of San Francisco. A near-ruin when they found it, the place had once been an elegant estate. It still had a hilltop view of the Pacific, a fireplace you could walk into, and even a grand piano neither of them could play.

Of course, Clyde, newly graduated from college, and Niki, unemployed and a college dropout, couldn't have afforded the rent on the mansion—even in its decadent condition. So they made it a commune of sorts, composed of cousins and college friends.

Abutting the property on the back was another old house boiling with a tribe of oddballs and sprouting suburbs of tents and buses done up in wild hues of house paint. Their neighbors' leader was named Timothy Leary. Clyde and Niki vaguely grasped what these

people were about: wild parties, drugs, group sex. They felt some fringe connection only because they, too, believed in making their own rules, that their lives were limited only when imagination failed. But neither had ever felt the need to stimulate their imaginations with drugs of any kind, or sex with strangers. They had never even had a drink. Niki had been enough of a nonconformist to want to steer the other direction when her peers began to rebel in that way. And Clyde had seen more than enough examples of what drink could do among his neighbors in the trailer parks.

Not that Clyde was uncomfortable around the scene bubbling up out of San Francisco, pulsing from the loudspeakers just beyond his backyard. He went to the parties, too, then drove everyone safely home. Undoubtedly, there was pressure to join in, but as always, Clyde was oblivious to pressure. He didn't take hints. He didn't even hear them.

The Butchers' commune contained conventionally separate bedrooms. And if there was a lack of sobriety, it came from high spirits and high hopes, not chemical compounds. But they had other problems to contend with. They had barely begun moving in when a co-owner of the hacienda, a man they hadn't met, dropped by to welcome them. He wore a cowboy hat, a bandolier, and a sidearm. "I'm your landlord," he announced, "and there's something I want to show you." They followed the man off the porch uncertainly. "See that can over there?" he said. Suddenly, he hoisted his weapon. *Boom!* The can hopped. Clyde and Niki jumped. The landlord neatly flipped his pistol back in his holster. He eyed Clyde narrowly. "No trouble out of you," he said.

Little did he know.

Clyde had moved into the hilltop mansion with the first of his great plans for the future: He and one of his roommates, a college buddy named Peter Portugal, were going to construct some of the greatest buildings ever built—out of balsa wood and glue.

This scheme had grown out of Clyde's response to a lack of talent. As a student in architectural school, Clyde faced up to the fact that he sketched like a grade-schooler. He couldn't draw an elevation to save his life. To compensate, he used his woodworking skills to craft elaborate models, and his aptitude for photography to make the models look real. He spared no effort to defeat the limitations of scale. He'd scout for days in the coastal redwood hills to find a stand of dwarf trees that could serve as a towering forest in which to place his model houses. For interior shots, he made his own pinhole camera, the size of a matchbox, that held a single frame of 35-mm film. Clyde liked to put his pictures beside photographs of actual buildings and ask which one was the model. As often as not, the people he asked failed the quiz.

Clyde's ability with the technique had made him a star at Cal Poly. The architecture department built a darkroom and put Clyde in charge. He taught others how to use a camera, how to develop film, how to print. Clyde didn't know himself, so he made it up as he went along. He learned about cameras and lenses, enlargers and chemicals, by reading the instruction sheets shipped with the equipment. He discovered concepts of focus and depth of field by blundering ahead, stumbling onto what worked, and what didn't.

Like generations of ambitious students before him, Clyde believed that excitement and respect for his work in the classroom would translate to success once he'd graduated. Others might need a humble apprenticeship with an established architectural firm. Not Clyde. He and Portugal, a glib, affable Californian with a knack for making friends, decided to get right to it, starting an architectural modeling company they called Building Perspectives.

The response was as rapid as they had imagined. They found no shortage of interest and had jobs lined up the weekend they graduated, including one for Bank of America for two thousand dollars — a colossal fee to the young men.

And there was no need for a stuffy office in a city. Working in their surreal hilltop mansion, Clyde and Peter completed the project in four days, without bothering to stop for sleep.

Two grand in four days! Instant success!

Except that when it occurred to them to divide the fee by the number of hours worked and figure in expenses, they calculated their net return at something under two dollars an hour. As they labored on other projects, a pattern developed: The models were great. Everyone wanted them. But nobody wanted to pay what they cost to produce. No matter how hard they worked, they never could make enough money.

This was the first shock for Niki, who had assumed Clyde would provide the bulk of their support. Now she had to support him. The second shock was how she had to do that. Niki had grown up in a world where children expected to graduate from college into jobs that showered them with pay and praise. But she had quit college after her freshman year to marry Clyde, and in the real world, the work she found offered almost nothing and demanded more than she wanted to give. She held various jobs, from telephone operator to bank teller, each day driving down the hillside past Leary's thumping commune, past the cowboy landlord taking his morning target practice, into a world of conformity and time clocks.

While she struggled with the routine, there was trouble brewing back at the ranch. Clyde and Peter had become demons, working feverishly to produce enough product to cover their expenses, attacking model after model with a form of tunnel vision. As they worked, the hundred-year-old pine floors of the big house sank beneath debris that quickly grew to a depth several projects deep. Visitors watched this process with fascination and occasional distaste, and some reported back to the pistol-packing owner.

Returning from San Francisco one evening, the Butchers found the road to their home blocked by logs. They swung back to town

and called the sheriff's office. The deputy on the phone knew their landlord. "Don't even try to go up there alone," he warned them. Three patrol cars met them at the barricade, and Clyde was put in the middle car for a drive up to the hacienda to collect their belongings. The deputies made Niki stay behind. As the officers waited for Clyde to pack, they held their flashlights away from their bodies in the darkness, fearful of drawing fire.

The Butchers moved to an apartment in San Francisco and tried to keep the business going, but their debt piled up faster than orders. They ran out of money for supplies. Clyde especially suffered in the city, despising the crowds, the faster pace, and the grime. He and Peter decided to call it quits.

But Niki had become pregnant, and Clyde needed a job. They stayed on in San Francisco, where he found the kind of work he had been avoiding: an apprenticeship at an architectural firm. He stuck to it through the birth of their daughter, Jackie, learning only what he had already suspected—he was born to be self-employed. Working on a punch clock was like holding his hand over a candle. A year after Jackie's birth, with Niki pregnant a second time, he chucked the job. He had no prospects, but no anxiety either. He was taking his young family home—to his parents in the high desert.

The truth was that the Butchers were in no position to help prop up a floundering young family. Clyde Sr. had years earlier fallen victim to his work, not the radiation releases that had poisoned undocumented scores of other weapons-plant builders, but a simple construction accident that had crushed his foot, permanently crippling him. On disability pay, he and Edna had retired to a small trailer east of Los Angeles, near a rugged ranch town called Beaumont. Clyde had worked his way through college with jobs his father's union had found for him, and it was a good thing, because the Butchers didn't have a dollar to spare. They survived on a strict bud-

get, illustrated by a house rule: The trailer air conditioner went on only when the desert temperatures climbed above 110°.

When Clyde arrived, Niki and baby Jackie in tow, he found his parents in bad straits. His father's crushed foot needed constant nursing for infections that eventually would culminate in gangrene. Even so, there was no question about making room for three more in the small trailer. Clyde was always welcome, no matter the duress. And the duress was great. Niki was nauseated with morning sickness and sleepy most of the time, worn down by the heat, oppressed by a monotony of rock and sand. Raised among sequoias and mountain rivers, Niki could see no beauty in barren desert. It seemed lifeless and geometric, and she felt as if she had landed on Mars. But Clyde had an inbred immunity to discomfort. The cramped space, the shortage of cash, the heat and dust, all lacked significance to him. He found the open spaces, and the open hours, exhilarating. His days

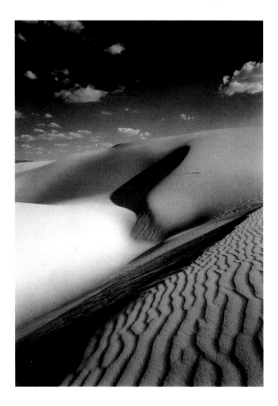

spread before him like invitations, time to hike, to photograph, to hunt, to enjoy his parents and his new daughter. He felt cleansed of San Francisco, and he was in no hurry to go anywhere.

Niki begged for space. The best that Clyde could offer was a place of their own. Small comfort. Their new home was another trailer, dilapidated, lacking even windows with glass. Clyde passed the next few months in a kind of sleepwalk, unable to decide on his next move. While he procrastinated, Niki counted the days like a prisoner. They took a day trip to San Diego, and the cool, sweet sea air nearly made her drunk. But Clyde wouldn't be pinned down.

Then one night Clyde went off hunting at a valley watering hole. The light from their trailer drew a swarm of insects—about the size of dragonflies—chased by bats through the trailer's paneless windows. Niki kept the light on, more afraid of not seeing the invaders than of seeing them. She huddled in a chair with her crying baby as the bugs swooped. The hardness, the cruelty of the place, consumed her courage. Coyotes howled in the hills. She imagined them stalking Clyde. She fought for breath. Clyde came home to find her weeping in a chair, nearly hysterical. He was gentle, apologetic, conciliatory. They'd get out of this place, he vowed. All Niki had to do was point a way. She pointed west—toward the Pacific.

Clyde found a job making his miniature models in Los Angeles, but predictably he hated the smog and sprawl more than he had disliked San Francisco. Refusing to live in Los Angeles, he found an apartment in Huntington Beach, a small sea town ninety miles south. In Huntington, their son, Ted, was born. But even with two babies and an income, the Butchers resisted a conventional lifestyle. Clyde commuted nearly four hours a day. Niki longed for more time together as a family and decided that her only recourse was to drive to work with him. So each day she bundled up her babies for the ride into Los Angeles. While Clyde worked, she took the children for

strolls through suburban neighborhoods that the Butchers would never be a part of, letting them nap under trees.

At least Clyde prospered in his new job. He was assigned to construct models for a design team creating San Francisco's signature skyscraper, the pyramidal TransAmerica Tower. He dove into the work. Eventually, the Butchers saved enough to trade their rented apartment for a condominium of their own.

But in the next two years, the California real estate market cycled into a steep depression, and the building industry began to lay off workers. Clyde never counted on being among the unlucky ones. He just hadn't conceived that his energy and flair wouldn't protect him. One day he found a dismissal notice on his desk. He brought it home, still enclosed in a small envelope, and gave it to Niki without a word. The realization of his expendability crushed his ego and doubled his disdain for corporate work. But his aversion to a salaried job was nearly irrelevant. Almost overnight, no one was hiring architects anyway.

Now Niki was the cheerleader. Maybe this was good in the long run, she told him. Clyde would be happier self-employed. Friends tried to tip him off to temporary opportunities. One, who had always admired the black-and-white landscape photos Clyde had made on camp-outs and motorcycle trips, urged him to enter a weekend art show at a local shopping center. It was a suggestion that would shape the rest of his life.

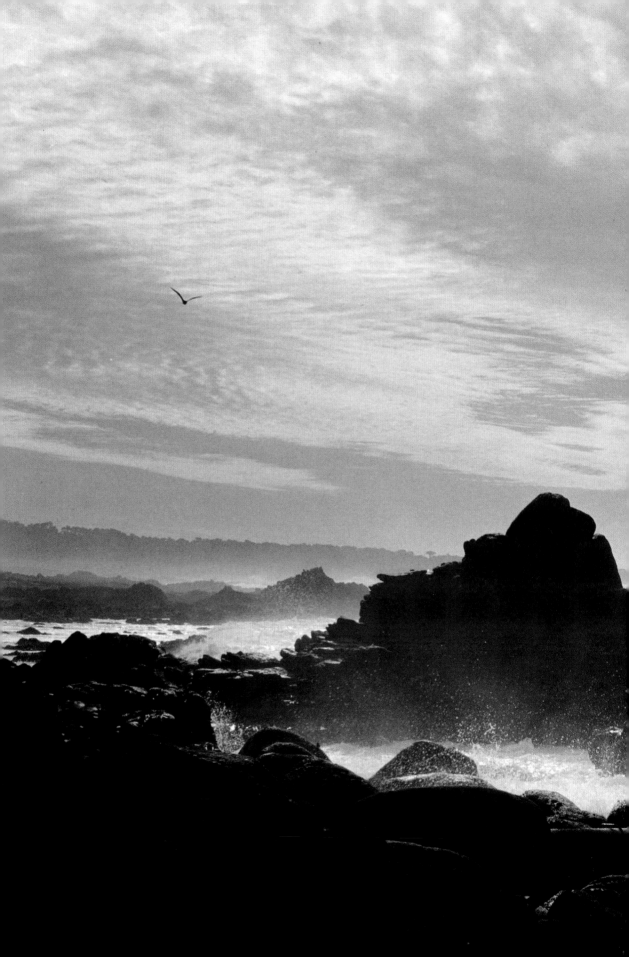

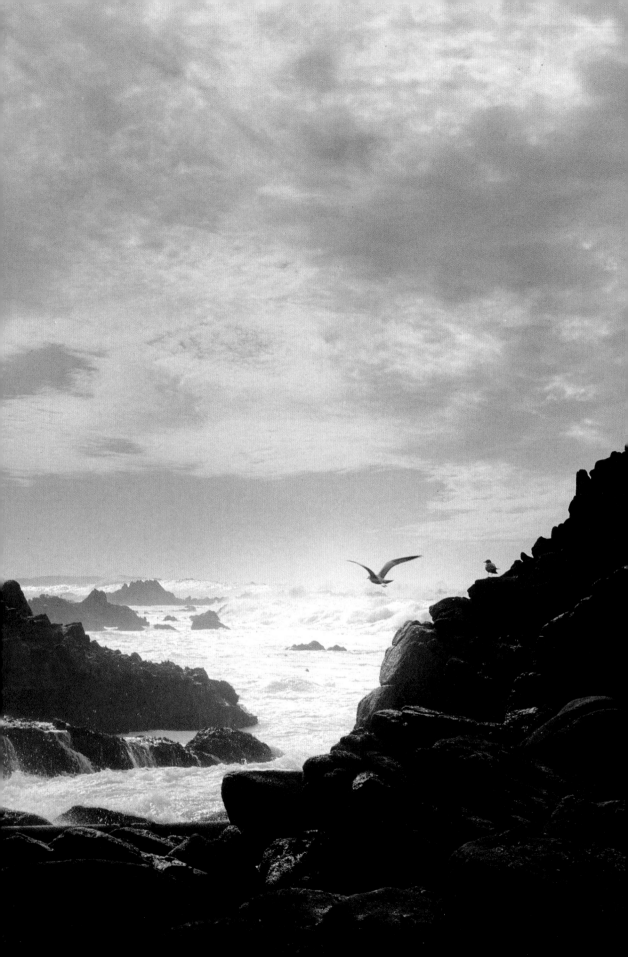

4. Navigating the Storm

Clyde had grown exacting with the photos he took for his architectural models, but he'd never thought of his landscape photos as anything more than a hobby. He didn't even have a darkroom of his own. On vacations in Yosemite, Clyde had discovered the work of the park's resident photographer, Ansel Adams, recognized his genius, and tried to imitate it. No, that's not right. Clyde wanted to do landscape even better than Ansel Adams. His ambition was not quite as absurd as it seemed. Clyde was good from the beginning, intuitively innovative, always searching for unconventional angles to convey grandeur and natural dynamics, sometimes photographing directly into the sun. The effects were stunningly odd, sometimes breathtaking. Friends *ooh*ed and *ahh*ed over his photos, but despite his ambition, Clyde knew he was no professional. To have enough photos to sell, he'd have to take some off his walls. Then again, he had nothing to lose by putting up a booth.

As the weekend show geared up, he watched the crowds with disbelief. People lingered over his pictures, picked them up, praised them, then handed him twenty-dollar bills. By show's end, he had a profit equal to a week's pay as an architect.

Money for nothing. No, better than that: Money for something fun, something he loved. He had a vision: never again anyone telling him what to do, never again long commutes, never again a tie around his neck. He could throw on old jeans, tote a camera through the hills—and get rich on weekends. Clyde cleared out space over the garage and set up a darkroom, and within weeks was churning out dozens of black-and-white landscape portraits and driving to shows all over California. The amateur had gone professional.

Just barely professional. He soon learned what any itinerant artist could have told him, not that he would have listened: Costs of equipment and film and paper, and wood and glass for framing, and gasoline and meals on the road, quickly eat up the five dollars to fifty dollars from each hard-earned sale. Clyde returned home with barely enough cash for groceries. Making the condo payments was impossible. It wasn't long before he and Niki were homeless again, forced to move into a tent trailer.

By now the Butchers were good at crises. Run off a mountain by a fast-draw landlord, rejected by the working world, eaten alive by desert bugs and howled at by coyotes, Clyde and Niki had developed an equanimity in the face of hardship, a gritty sense of optimism. Somehow, they knew they would get themselves out of this.

They shuttled between state and county parks, rotating back and forth to each site as their two-week camping permits expired. They bathed their children in cold showers and cooked off barbecue grills. They spent nights watching the constellations form, listening to cricket concerts. The hardest part was the dirt. Ted had reached crawling age and found his way into soot minutes after his icy baths.

To get the squirming toddler back under a camp shower, Niki had to plunge in with him. Then five minutes later, he had hit the dirt again, with God knew what in his mouth. Niki envied the toughness of Indian and pioneer women, wondering how they managed to raise children in the wilderness. She knew she could never match it. But she also discovered that she treasured the experience, particularly her mornings, when she would emerge from the tent into a cool, green world vibrating with beauty as her husband strode into the tall forests to capture it with his camera.

The Butchers' homelessness lasted less than a year. Within another year, they had more money than they ever imagined.

Clyde was discovered and made successful while hawking pictures at a Los Angeles shopping mall, just hoping to cover his latest camping fee. A customer passed his booth and stopped, surprised by the black-and-white images. "You're as good as Ansel Adams," the man said. One by one, he inspected Clyde's pictures, praising each one, getting more excited. He wanted to know everything. What cameras did Clyde use? What lenses? How did he print? Did he have more pictures to show? Had he considered a partnership?

The customer was Peter Gates, a Los Angeles businessman looking for opportunity. Gates had been a manager for JCPenney after college, then inherited a substantial stock portfolio. Clyde's pictures looked to him like a potentially good investment. Under the arrangement he suggested, Clyde would print pictures in mass quantities and Gates would sell them to Penney's as wall decor. Clyde was eager, but his struggles in art shows convinced him that they would need a bigger variety of pictures than a single photographer could provide. The two men brought in a third partner, a photographer named Richard Pucillo.

They named their business Eye Encounter. Clyde thought he had finally found a paycheck, but after two weeks, neither of his two

partners had mentioned one. When he asked, Peter Gates explained that new businesses usually didn't pay salaries to partners; every cent went for start-up costs. Until they were making money, partners survived on their own.

"I have a wife and two children in a tent," Clyde pleaded.

Peter looked puzzled. "But don't you have investments?" asked the dapper Los Angeles heir.

The partners conferred over Clyde's lack of an investment portfolio and decided to hire Niki as office manager. The Butchers then moved into a warehouse that the partners rented to use for making picture frames and set up housekeeping in the loft.

Eye Encounter did well. Penney's was the first of a group of department-store chains enlisted as buyers by Peter Gates. Their biggest challenge was meeting the unexpectedly strong demand. They had to learn the finer details of their business—how to mount and frame and ship their work; how to order supplies in mass quantities; how to find capital for expansion. In dealings with the companies buying their product, they were mostly bluffing. But they bluffed just fine. Within a year, their company had taken on fifteen employees.

Clyde finally drew a salary, enough for the Butchers to afford an apartment. He also began to extend his range, making photo safaris all along the Pacific Northwest coast and to Hawaii. But he soon discovered black-and-white images held him back; other photographers competed with color, selling wall decor more compatible with a current suburban obsession for gold curtains and green carpets. Color meant more money. So Clyde went color.

The first thing he noticed was that the detail vanished from his pictures. On 35-mm color film, small images blurred and merged on the postage-stamp-sized negatives. Clyde, used to the clarity of black-and-white, couldn't accept less. So he bought a five-by-seven-

inch box camera that made an image on a negative the size of a post-card. With larger negatives, Clyde began to make larger prints. And the larger prints suggested something else to him: a wide-angle lens to give more of a "you are there" quality. Clyde had already figured out that people liked to buy what they could identify with, and a large print with wide angles put the viewer right in the picture.

The partners also decided to switch from prints to color lithography for mass production, and, gradually, the science of marketing overtook the art of capturing beautiful images. Profit dictated every shutter snap. Each photo would be reproduced in small quantities and test marketed. The store computers would tell them which were most popular, then Eye Encounter rushed those numbers into production. Seagulls were very big. Mountains were not hot at all. Badlands and mesas didn't sell either. Foggy forests were good. To Clyde's surprise, people weren't all that interested in grandeur unless they could imagine themselves in the middle of it. Buyers seemed to crave a sense of intimacy with nature, albeit sanitized and spoon-fed in familiar packages. And Clyde became their agent. He wouldn't take a picture if he didn't think it would sell, and if it didn't have water, fog, or sunset, he knew it wouldn't sell. Niki thought Clyde had gone too far when he fastened little clocks in the corners of his framed lithographs. But commercially, it all succeeded beyond every expectation. A single popular image sold 250,000 times. They picked up new accounts from Ward's and Sears, and soon Eye Encounter had scores of new employees and million-dollar gross revenues.

But the Butchers weren't much interested in a mansion with a tennis court in Bel-Air. With their new wealth, they bought a twenty-six-foot sailboat. They sailed it across Bolsa Bay once, and when they returned to the dock, Clyde, his pants brine-soaked, his beard salt-caked, announced to Niki and the kids, "I won't spend another night at that apartment." And they didn't. They returned there to pack up

their belongings, then moved aboard the boat. After a few months, they realized they were too many on too small a boat, but the solution was not to move back to an apartment, but to trade up to a thirty-five-footer, the *Sea Shanty.*

The Butchers fantasized about simply pulling up anchor and sailing away. Eye Encounter had grown into a friendly monster, two hundred employees strong, one that consumed their private lives. As a midlevel manager, Niki felt trapped between the staff and her husband, the boss. They came to her with grievances, and she tried to broach them with Clyde in evenings on the *Sea Shanty* deck. Each office crisis preempted the intimacies of marriage. Their time together degenerated into bickering over business.

Financial pressures mounted, too. Eye Encounter's partners only slowly discovered that survival depended on more than talent and long hours in the office; that too much success too soon sometimes put businesses under. At Eye Encounter, sudden strong demand for their photographs left the partners unable to fill orders. They grew desperate for cash to expand, but had too short a track record to interest banks. Their search for credit led them into higher-risk financing.

There was nowhere Niki could escape from the pressure. Living in a tent in a series of state parks began to seem idyllic in comparison. She told Clyde she wanted him for a husband, not a business partner. She feared their marriage was falling apart.

Clyde's solution was a long vacation. He rigged the *Sea Shanty* for heavy seas and plotted a three-month cruise to Mexico. Niki resisted, worried about the safety of Ted and Jackie, just seven and eight, and whether she and Clyde would be at each other's throats. Finally, she agreed that he could sail with a crew of friends to Puerto Vallarta, where she would meet him with the kids. If everyone got along and the boat looked sound, they would sail back to California

together. Without telling Niki, Clyde stacked the deck in favor of the high seas by buying them one-way plane tickets.

Clyde set out with a small crew, in tandem with another boat piloted by a friend, Richard Hall. As they sailed south, it dawned on them that they were entering a different world. The most obvious difference was the silence of their small radios. There was no radio in Mexico. There was no coast guard, no communication, nothing. On the evening of the sixth day out, Clyde figured they were still 135 miles from their destination, Cabo San Lucas, at the tip of the Baja peninsula. The port was guarded by a perimeter of jagged rock, no place you wanted to slip into at night, which is just what they would do if the winds held. Clyde decided to delay: reef the mainsail, reducing its power by half, and fly only a small storm jib, just enough to hold them on course until they drifted into Cabo San Lucas after daylight. In the meantime, they'd just take it easy.

Clyde was belowdecks eating dinner when a cannon shot of wind tumbled out of the Mexican mountains. The freak blast of air, moving between seventy-five and one hundred miles an hour, knocked the *Sea Shanty* on its side and held it there. Inside the cabin, everything exploded. The crew barely made it up on deck. If they hadn't decided to reef the mainsail, they would have been in the water. As it was, they struggled for two hours to get the mainsail down the rest of the way. By midnight the seas were running twenty feet, burying Clyde's little craft in a black staircase of waves.

The ten-ton boat was riding the mountains of water like a surfboard, the craft emitting an eerie, high-pitched hum as it shot forward at twice the speed that was supposed to be its maximum velocity. Then in the morning the storm died, and the wind with it. They were becalmed, within sight of their destination. Clyde started the engine and motored in. Safe at anchorage, a crewman leaped from the boat to kiss the earth. But Clyde never felt better. He'd rid-

den out a storm, only to discover it had blown him directly to where he'd wanted to go. Years later, Clyde would recognize that as a pattern in his life.

In Cabo San Lucas he dismissed the crew and reunited with Niki and the kids, anchoring the boat off a fishing village near Puerto Vallarta. The hotel there was accessible only by boat and donkey, and its beach was a carpet of sparkling white sand washed by a pristine surf. Under the hotel's thatched roof, rooms were lighted by oil lamp, beds covered by netting, bathwater warmed on charcoal fires.

Each day, they sailed, exploring the wild coastal isles, where they surprised flocks of blue-footed boobies and chaotic colonies of frigate birds. They anchored on shoals of ancient shark vertebrae, snorkeled below silver manta rays with twenty-foot wingspans, and bartered with fishermen who laughed derisively when the Butchers tried to tell them a man had actually walked on the moon beaming over their heads.

When they lost a dinghy, they hiked into the high jungle hills, where they found a boatbuilder to cut and craft a replacement from a single tree. After long, complicated negotiations in their broken Spanish over the size and design, they agreed to pay $110 plus a rod and reel. Then they thanked the boatbuilder, who smiled at them and responded, in flawless American English: "It will be ready next Friday."

On their meandering sails, the southeast Pacific dwarfed and humbled Clyde and Niki, drew them closer. They discovered the distance that had grown between them was external, now all but meaningless. Storms would come, they realized, then and later. In their small craft on the wide ocean there was no place to go. There was nothing to do but hang on, have faith, and wait for the rough weather to pass.

The trip helped save their marriage but not their business. When the Butchers returned to California, company finances had

worsened. High interest from short-term loans strangled their profits. Their lender disputed accounts and held back checks. Capital dried up, orders were dwindling. People weren't being paid. Soon it was obvious that a decision had to be made: close Eye Encounter or sell it.

Clyde brooded over the choices. Selling and risking the jobs of two hundred workers sickened him, but he saw no other way out. He also felt cheated. He hadn't failed because nobody wanted to buy his photographs—they were selling by the thousands. He had failed because of things as mundane as accounts receivable, and because his financers were better at manipulating figures than he was. The stress reduced him. One morning, Niki noticed a physical change, one so startling that she said nothing to him until she could convince herself that her imagination hadn't fooled her. Almost overnight, Clyde looked aged. His hair had completely grayed.

In the end, the partners agreed to sell to a Utah investment group. Clyde's partners took their money up front, but Clyde negotiated an annuity that would provide a monthly income—in return for his promise to never compete with the buyers. He could photograph and sell pictures locally, but he could not start another national print manufacturing company.

Clyde hated the terms but had to accept them. Secretly, Niki felt relief. They opened a souvenir shop in Huntington Beach and sold Clyde's framed photographs with the small clocks anchored in the corners. The shop prospered, and finally had six employees.

Cushioned by his annuity, Clyde tried a life of leisure. He built a twenty-foot sailboat, which he christened *Sea Shanty II*, and took the family on vacation, trailering the boat to Florida, where they sailed for months. Florida was a sailing paradise, its endless bay-studded coast and gentler, warmer waters a stunning contrast to California's rocky precipice, and the Butchers talked about one day moving there.

But Clyde had unfinished business back home. He never accepted his loss. With what he had learned the hard way at Eye Encounter, he believed he could start another company and make it work. Only the annuity agreement stood in the way. So when he returned to California, he gave up the money. He found a new business partner, and they set out to create another company, bigger and better than Eye Encounter.

Bigger was the easy part. Clyde leased a huge warehouse and began ordering vast quantities of supplies. Niki saw a cycle starting over again. "If you want to do this, just leave me out of it," she told Clyde. They agreed not to talk about business, but Niki saw the bills coming in and worried. Clyde had no customers yet. But the monthly lease on the empty warehouse alone cost seven thousand dollars.

In the summer, Niki embarked on a month-long trip to Missouri in a motorhome with her sister and two cousins, leaving Clyde with the kids. It was great fun, just the girls. But the fun lasted only a few days before Niki called home.

Clyde's voice was flat, emotionless. "We've lost everything. We're bankrupt," he told her. "What we have left is all loaded in a truck. When you get back, we're leaving for Florida."

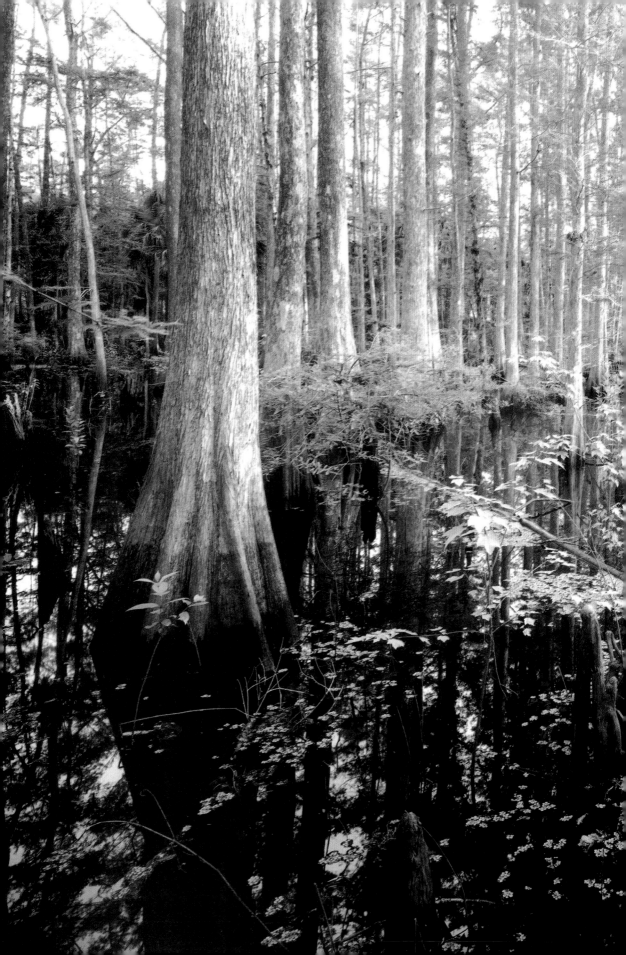

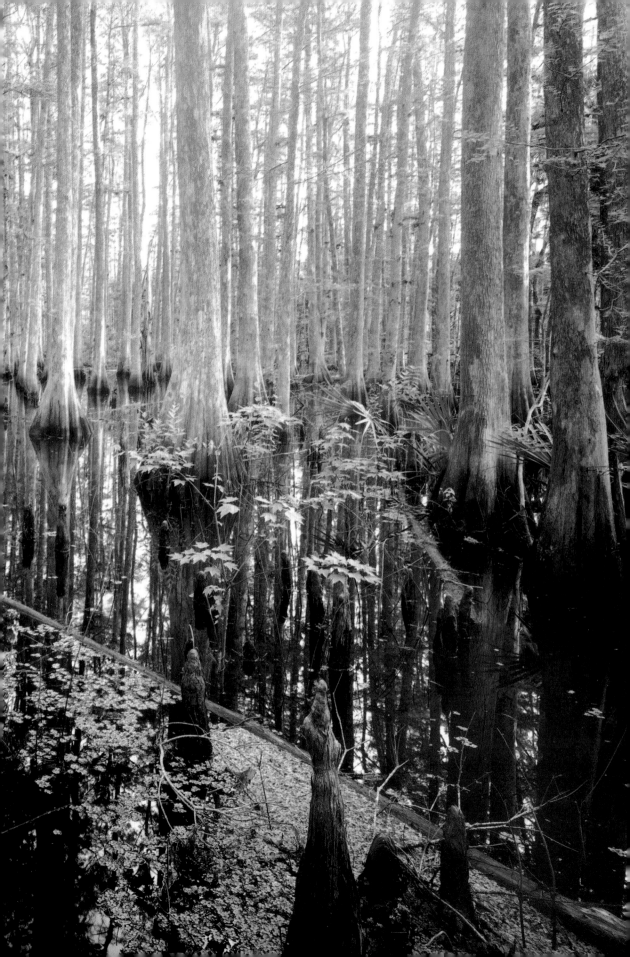

5. *Night Vision*

Four years later, traversing Florida on its two-lane tractor-trailer backbone, U.S. 27, Niki pointed out a scribbled message on the planks of a gray, roughly nailed billboard: LADY, IF HE WON'T STOP, HIT HIM IN THE HEAD WITH YOUR SHOE.

Niki grinned while Clyde groaned. She had forced a promise from him to heed the goofy sign and stop at the roadside attraction, but as they logged each indifferent mile across a landscape of baking agriculture, Clyde's foot leaned harder on the pedal. His mind was on boats and beaches, and the fact that he could reach their home by the Gulf of Mexico in two hours. He was doing sixty. He wished he could be doing eighty.

In crisscrossing the state to art shows, they had passed these corny billboard signs a thousand times and never looked twice. The place—advertised grandly as "Gaskins' Cypress Knee Museum"—

was among a dozen blighted sideshows on Highway 27 that typified everything about Florida Clyde found disappointing. He couldn't imagine that somewhere between all the juke joints, barbecue shacks, gator-wrestling pits, and army surplus depots guarded by tilted howitzers there might be someplace worth stopping for, much less photographing. Monotonous citrus orchards and fields of sugarcane stalks spread as far as Clyde could see. Harvest-bearing tractor trailers kicked up whirling clouds of topsoil like mechanical dust devils, rumbling toward smoke-belching processing factories. Oranges and sugar took the best there was. The rest was muck and snakes and mosquitoes, sinkholes and flat vistas of overgrown water weeds. This was the real Florida in Clyde's eyes. Whatever there once was of value had been turned by the plow or paved over. Everything else was swamp, and if it weren't for offshore sailing, Clyde would have abandoned Florida long ago.

Now, Niki had stumbled on something. On a solo trip weeks earlier, she had stopped on a whim at this place with the quirky sign. Still excited hours later she had told Clyde of her discovery, but he had shrugged it off. A roadside attraction? Of cypress knees? Clyde only vaguely knew what they were—strange, gnarled knobs of root that spindle out of the ground at the base of swamp cypress. The fact that someone had built a tourist attraction devoted to these gnarly oddities, some of which allegedly resembled celebrities and historical figures—Carmen Miranda and De Gaulle, among them—told Clyde all he needed to know about the desperation for diversion on Highway 27 and the peculiarities of the local populace. But it wasn't the funny "museum" itself that had captivated Niki, it was what she discovered across the road: beauty unlike anything she knew existed. Somehow Florida's developers had left untouched a natural spectacle, a treasure ancient yet alive. A primeval cypress swamp flourished ten yards from the highway, an intact piece of the Florida of five thousand years ago. And she knew Clyde had to see it, too.

The attraction's caretaker, seventy-five-year-old Tom Gaskins, greeted the Butchers with a grin consisting entirely of gum. He wore a cracker straw hat and overalls, and trod barefoot on the black muck he had lived on and protected half a century. Old Man Gaskins led them through his jungle, canopied with oak, black gum, grape-vines, and cabbage palm, all the while chattering about his 1937 patent for "Articles of Manufacture Made from Cypress Knees." He apparently believed the exclusive right to trick out cypress knees as statuary was a great coup, keeping at bay the thousands who plotted to pirate his gold mine. He was still rambling when they reached the start of a plank catwalk, five feet high, barely a foot and a half wide, loosely constructed of old bridge timbers. Clyde tested his weight on it, uncertain. He peered through the jungle, trying to see where the planks led. Barely fifty feet from the cane-laden trucks howling down U.S. 27, the rickety walk made a bend, disappearing into the unexpected realm of ancient wilderness.

Clyde had the odd sensation of floating, almost as if he had walked out of a dark cranny into midair. A soft breeze sighed from far off, alive with the scent of sweet water and things growing. It was the cleanest thing he'd ever smelled, absent even a hint of rot or decay. Before him, the graying catwalk stretched into an enchanted forest that sprouted from the mirrored surface of a clear lake. The water, filled with thousands of minnows, was so clear he could see through it like air. The trees, bedecked with bromeliads, flowering vines, and orchids, were tall and narrow. But near the earth, their trunks swelled to a graceful immensity, sinewy and moss-covered, like the base of a drip candle. The roots disappeared into liquid soil. The cavernous space between water and canopy blossomed with white, purple, and yellow flowers of water plants, strangler figs branching out from coiled roots, quaint gnarled trunks of pond apple and the occasional smooth, gray arc of a royal palm reaching toward the light.

And it was the light that captured Clyde, pure and clean as the air and the water, more powerful than both. It slanted through the dense and complex foliage and lifted off the splintered water like a spirit descending to kiss the earth, then rising again to heaven. It struck him, his eyes, his skin, his nostrils, like a revelation. His first articulate thought was: I should take pictures in here. Not "I need" to take pictures in here, but "I should." After a decade of photography as enterprise, of choosing subjects with the eyes of an expert market analyst, Clyde was moved as he hadn't been since camping at Yosemite with Niki.

For the next few days, Clyde came back to the Cypress Knee Museum with his camera. For no reason he could later fathom, he had loaded it with black-and-white film. The photographs he made were his first in black-and-white since leaving California. They weren't very good. It had been a long time since he'd processed black-and-white negatives. Clyde never thought of trying to display the images. The next week, he was off to the beach, shooting sunsets in color. He had a living to make.

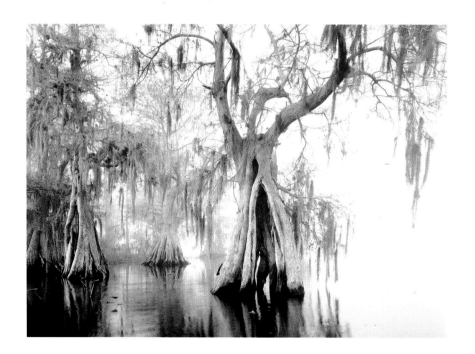

It had taken nearly all of his four years in Florida to recover from bankruptcy in California. After moving cross-country in 1980, they were virtually grounded. Creditors followed them to a house they rented in Fort Lauderdale, and repo men glided into their drive at night, hauling off every vehicle they owned—van, car, and motorhome. Niki heard the men rustling in the dark, slipping chains on the vehicles, barely stealthy, scornful of deadbeats. Clyde immediately put the incident behind him. She flinched with shame. The sound outside her window bore the rattle of failure. She partly blamed her passivity for their troubles. She could have done more to stop Clyde, but she had backed off.

It had been that way all their married life. Niki had let Clyde lead without question. Now she vowed to never abdicate equal partnership again. She would take responsibility for herself, stand up to Clyde and say no if she had to. The next time she landed in a mess like this, she wanted to know she had put herself in it.

Clyde had come to his own conclusions. California had been a lesson in the dangers of financial lust. Business pressures had drained his creativity and prematurely aged him. Losing everything gave him a chance to start over. In Florida he would have time to sail, to travel, to get to know his children. He still had his California scenics to sell. They would get by. The best times of their lives had occurred when they were poor, he reasoned, the worst when they had money and no time for the things that counted. He told himself that the collapse of his finances had been a mistake, no more. It was a life experience, over and done. Only the future counted.

When the Butchers first arrived in Florida, the future seemed a long way off. The night of the repo men was only part of their penance. They spent their days manufacturing Clyde's picture clocks—mounting clocks in corners of his photos. Making picture clocks in a rented Fort Lauderdale garage marked a drastic demotion

from running a company of two hundred employees, but the Butchers knew they didn't have to like it. They just had to do it.

The Butchers had come to recoup in Florida not only because they loved the warm waters, but because a man named Peter Van Overbeek believed in them. Van Overbeek had been a sailing friend of Clyde's in California. They met on the docks in Huntington Beach, and Clyde kept Van Overbeek's car while he sailed off the coast. When the Butchers went belly up, Van Overbeek offered to help them get back on their feet. He had a law practice in Fort Lauderdale and was always looking for investments. Clyde interested him. He thought the picture clocks, a step up from the usual tourist kitsch, would sell well in Florida souvenir shops.

The lawyer created a corporation, hired Clyde and Niki, then sold their clocks to craft shops.

For a year, Van Overbeek paid their bills and managed their money. While Clyde and Niki waited for the courts to complete the bankruptcy, they got by on a tight budget and a short leash. If Niki wanted school clothes for Ted and Jackie, she went to the lawyer for the money. To buy food, she had to accept an allowance. She hated asking for it; she felt humiliated. But they had no credit cards, no checkbook.

Eventually, the Butchers once more turned to the weekend art show circuit to liberate themselves. At a parking lot show in Fort Lauderdale, Clyde met David Leach, an underwater photographer, who offered to exhibit Clyde's pictures in his booth and split the profits. The extra income gave the Butchers a chance to plunge back into art shows on their own. They amicably ended their partnership with Van Overbeek, moved to Fort Myers on Florida's more affordable west coast, and began traveling the circuit.

Clyde's parents joined them in Fort Myers, bringing a motorhome with them from California, which Clyde borrowed to get

started. But he and Niki and the kids were still living hand to mouth, budgeting each art show trip down to loaves of bread and peanut butter jars. On a trip to a sidewalk show in New York City, they stayed at the Plaza Hotel—not in the Plaza, but at it—in a parking space outside, near their Central Park booth. This was Clyde's first trip to Manhattan, and it was there he learned that all the peculiar events of his life—from armed landlords to sea storms—paled in comparison to navigating a thirty-foot motorhome on Fifth Avenue. But the adventure had only begun. Around two A.M., Jackie crept to Clyde's bunk. Two men stood beside the trailer arguing loudly. "They're yelling about killing somebody," Jackie whispered. All four Butchers crawled below the motorhome window, listening as one man profanely blamed another for "blowing" a hit in New Jersey. "Now I gotta do it myself," he shouted.

In the morning, the groggy Butchers, who hadn't slept well, confronted their next uniquely New York crisis. One of Central Park's carriage horses, driven to the point of exhaustion, had collapsed right beside their booth and couldn't get up. Public-works crewmen and police were summoned, and four attempted to get the horse upright, one each pulling at the head and tail, and two more tugging at the horse's sides. But the suffering animal wouldn't budge. The struggle with the horse consumed most of the day until a veterinarian was called. Ted came running into the booth, horrified. "They shot the horse!" he cried. Clyde said he hadn't heard a gunshot. "With a needle, Dad!" Ted cried. The dying horse had been helped on his way by lethal injection. For the remainder of the day, police and carriage drivers argued over the best means of removing the remains. Eventually, a tow truck was called, and the carcass was hoisted onto a flatbed truck. The Butchers left New York at a gallop.

In Florida, Niki had begun to experiment with a camera, too, and practiced a technique of photographing old beach houses and

docks with a Polaroid, then hand-painting the prints in pastel colors. She surprised herself and Clyde by winning awards for her pictures at shows and occasionally outselling him. Niki's success jolted Clyde's ego. He found himself resenting her sales. Niki confronted him. "You've either got to be generous and kind when I do well, or I'll stop," she said. "No, don't stop," Clyde told her. "I'm having a problem with it, but I'll outgrow it. Just bear with me."

Clyde was honest enough to realize that what really bothered him wasn't Niki's success, but his own lack of growth. He saw his pictures as sappy, trite, too blatantly commercial. He realized he had to try harder. His photographs got bigger, more dramatic in composition, deeper in texture. His injured ego had become his best motivation.

Clyde and Niki were beginning to thrive again, but the children hated Florida: the oppressive humidity, the flat, sparse homeliness of a landscape so foreign from the West and, once again, the task of making new friends. Jackie was eleven and Ted was nine when they left California, but they knew they were losing what little stability they had been able to find in the camps and sailboats of their early, chaotic childhood. As boat live-aboards, constantly changing addresses, the Butcher children had crossed school boundary lines several times each year, starting one place in the fall, transferring at Christmas, then moving again by spring. The children attended at least fifteen different elementary schools. They learned a survival technique practiced by military children—to sell themselves, to radiate instant charm, to make friends quickly. They circulated widely at each new school, embracing every race and ethnic group, joining as many clubs and sports as they could. Their travels and years on sailboats gave them the worldly self-assurance to pull it off.

But under their veneer of maturity, Jackie and Ted were still children, and they craved permanence. Their last year in California,

they thought they had finally found it. They had remained at one school all year and had found a lasting circle of friends. Then virtually overnight, they were shanghaied across a continent by their parents. The move appalled them. It broke their hearts. Jackie let Clyde know in a loud voice. Ted confided to Niki about his depression in whispers. It typified their relationships. They each had a parent of their own.

Jackie's hold on Clyde was legitimized by every turn of her mouth, every gesture of her tall, strong body. She was his virtual twin, sturdy and solid like him and physically assertive. They met each other as equals, one moment laughing together, the next shouting each other down. Clyde felt he could deny his fearless daughter no freedom. The year the Butchers moved to Fort Myers, when Jackie turned thirteen, she insisted on taking her own vacation to see her old friends in California and saved enough for bus fare. Nervously, the Butchers watched their child, not even yet in high school, vanish in a haze of Greyhound exhaust. Days later, in Arizona, her driver got into a brawl with a passenger and was arrested, leaving Jackie and other passengers stranded in the desert until the next bus came along. When she arrived in Los Angeles, hours behind schedule, the station had closed for the night, and she was again stuck. But she talked a sympathetic driver into taking her to Huntington Beach.

Jackie mimicked her father in other ways. She was an *A* student, had an entrepreneurial bent, certain at a young age that she would one day operate her own company and never work for a wage. In high school, Jackie started a car wash and made eighty dollars in a single afternoon, blowing it all on a Hobie ride the next day. She loved art and showed an eye for composition, offering advice to Clyde that was not always solicited. And she sailed the Gulf of Mexico like an old salt, helping crew an all-women racer to a third-place finish against seventy male competitors.

Ted was as gentle as Jackie was aggressive. He found Clyde intimidating. His soulmate was his mother. They had shared a special intimacy from his first gasp of breath, when Ted gave Niki the gift of a near-painless delivery. Ted's birth had been blissfully easy, glorious, completely unlike Niki's agonizing struggle to birth Jackie. With Ted, everything took on a surreal, serene glow, spiritual and sacred. Even so, when the obstetrician had handed Niki her son, her first thought had terrified her: He will die as a young man. She told herself this wasn't a premonition, but the normal fears of a mother for her newborn son at a time when young men were dying in Vietnam. But she never forgot it. As Ted grew up, she preached to him about the evils of war. "If you ever get drafted," she'd tell the uncomprehending little boy, who simply wanted to play with his toy soldiers, "we'll understand if you feel you can't go, even if it means leaving the country."

Clyde wasn't sure how to handle his son. Ted, lithe and thin, had a way, a casual, aristocratic presence foreign to Clyde's roughshod desert roots. With Jackie, Clyde could speak his mind at a decibel level she could plainly hear. If she didn't like what he said, she'd yell back. But a sharp word could reduce Ted to tears. Clyde fretted that his son lacked grit. He tried to treat him differently from Jackie but couldn't. He awkwardly and gruffly tried to reach him, and usually failed.

Ted sensed his dad's ambivalence. As if to prove his latent virility, he threw himself into soccer, becoming a local scoring sensation in Fort Myers. He became a popular personality at school, a nonconformist, a spirited teenager eager for approaching manhood. Niki watched Ted coach others on the soccer fields, patiently explaining to small children the technique of dribbling downfield, and she pictured him one day as a teacher. But what Ted did best was have fun.

He had a circle of friends who practiced the standard Saturday-night teenage rituals of Fort Myers, spinning doughnuts in Ted's

Gremlin, passing joints, and sneaking into hotel Jacuzzis to recline in the steaming swirls and plot sexual conquests. In school, studies and play competed as priorities. For Ted, a day of dissection in the science lab concluded with the hairy corpse of a guinea pig, reeking of formaldehyde, pinned gaping and spread-eagled to the interior of a girl's locker. But when Ted and Jackie waged teenage war on Clyde, it required more cunning. Their friends kept parents off balance by letting their hair grow long and wearing dirty jeans and torn shirts. But Clyde himself scarcely knew what a comb was and wore nothing all day except cutoff jeans and sandals. Ted and Jackie shook Clyde up by blow-drying their hair, by using styling gel, by pressing their shirts. The sloppiest man in Fort Myers had the town's best-dressed teenagers.

Jackie graduated and enrolled in art school in Fort Lauderdale; she would probably return in a few years and start a business. Ted, in his junior year, was involved with his girlfriend. They had dated nearly eight months and had talked about attending college together in another year. Niki pictured, not really with alarm, the two getting married and living in Ted's room until they finished college. She saw them starting out as she and Clyde had—with just their dreams.

Niki felt she had arrived at the place she had always been aiming for. Their lives were moving along a track, finally smooth and straight. She and Clyde were art show veterans, both making money, improving each season. At forty-two, she was in glowing health, strong, vigorous, with sun-washed, outdoor looks.

Then, on an early June afternoon in 1986, Niki was standing at her exhibitor's booth at a Miami Beach art festival when she collapsed without warning. "The life went out of me," she told Clyde. She felt no pain; doctors found nothing physically wrong; all she could vaguely sense was a letting go, a giving up. Oddly, she was not afraid, simply . . . absent.

As Niki lay in her room from morning till night, she watched clouds float in the tiny square of sky she could see through the window by her bed. Each day the clouds would form and drift and re-form in the same pattern, some thin as muslin sheets, others puffing up like feather pillows. The drift of the clouds became her routine, the measurement of her day. She thought she must be dying.

On Father's Day, Niki and Clyde's twenty-third wedding anniversary, the rectangle filled and darkened, a gray shroud dumping rain. Niki had been sick for two weeks. She felt no better, but she gathered herself and got out of bed for Clyde. For Father's Day, he had asked for a favorite family pastime, a game of pinochle, the way they had passed days of isolation on sailboats in California. But Clyde's plans for a nostalgic afternoon fell apart. Jackie was unable to drive over from Fort Lauderdale, and Ted wanted to see a movie with his friends. Clyde, accepting a giant cookie from Ted, inscribed "World's Greatest Dad," put the cards away.

In an afternoon storm, Ted rode shotgun in a Nissan driven by his best friend, Brad. They picked up another boy, and the three headed for a mall movie, *Howling II.* The boys approached a broad suburban intersection in west Fort Myers unaware of an insane intrigue unfolding at eighty miles per hour blocks ahead.

Just a few minutes earlier, three miles east, a man named Matthew Mullin, driving his twelve-year-old niece, Deanna, home from a beach picnic, ran his Gremlin halfway through a red light, nearly hitting an oncoming Bonneville. Mullin was too drunk to see the Bonneville until Deanna yelled. Then he saw two men inside, cursing him. Mullin saluted them with his middle finger and drove on.

The Bonneville got right on top of him, and at the next gas station Mullin pulled over. He started to step out, then thought better of

it. From the Bonneville's passenger seat emerged a snarling loser named Dick Bush, furious over the interruption of a beer-drinking Sunday drive with his young nephew, Bill. Bush had come to Fort Myers trailing nearly two decades of arrests and convictions in New Jersey for forgery, larceny, burglary, fraud, aggravated assault on a policeman, and resisting arrest. He had once been convicted of sodomizing a farm animal. Like generations of rough characters before him, he had come to this settlement between ocean and swamp in hopes of a fresh start. Bush had a new wife, a year-old child, a job as a landscaper, and a clean record in Florida. But on this, his first Father's Day, he still had his temper.

Bush charged the Gremlin on foot and pounded his fists on the car roof. "Just go!" Deanna cried as the stranger's hands thudded above her head. Mullin hit the gas. The Bonneville took off after them, both cars fishtailing onto the wet road as Deanna fumbled to buckle her seat belt. The Bonneville veered left and pulled alongside, and Dick Bush flung his partly full beer can through Mullin's open window, striking him in the head. Deanna screamed, but Mullin just stared grimly ahead, beer running down his cheek. Then the Bonneville came along on the right, and a frog gig—a barbed spear— crashed through Deanna's window, grazing her shoulder. By now they had covered nearly three miles, both cars doing eighty, and they neared the crossing where Ted and his friends waited at the light to turn left. When Mullin saw the red light, he veered around the waiting cars and tried to run it through the right-turn lane.

The boys' Nissan appeared out of nowhere. Mullin didn't even have time to lift his foot off the gas. Everything just exploded as the two cars smashed together, killing Mullin instantly. Ted's friend Brad staggered from the wreckage, shoulder dislocated and ribs broken. He unconsciously stripped his pants off and urinated blood. He went back to the Nissan and hailed the boy in the backseat. "I'm not so

good," the boy called back. He was wedged in the wreckage, but unhurt. Brad then called for Ted. In the shotgun seat, Ted lay still, his heart torn in two.

At midnight in the Butcher home, Niki heard the knock in her half-sleep of lassitude. She listened as Clyde climbed down the stairs. He padded toward the door, more annoyed than concerned. "Ted's been caught for some prank and is in jail," he told himself. From the bedroom, Niki heard the door open, low voices, then footsteps of Clyde and other men going into the studio. The voices continued for a long time. She sat up and swung her legs over the edge of the bed. She sat there staring into the darkness. When the men left and Clyde came back up the stairs to her, his stricken face saying everything, she told him, "I need to go for a walk," and she went into the street in her nightdress, aching to run, to keep running. After a block, she collapsed, not from illness — now trivial, now distantly past — but from what had abruptly overwhelmed and replaced it: the dismemberment of her soul.

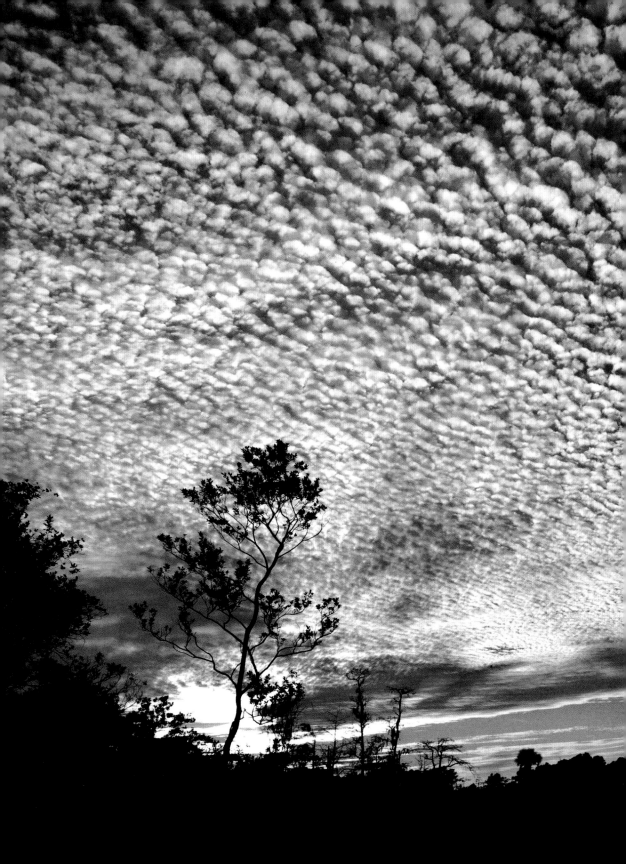

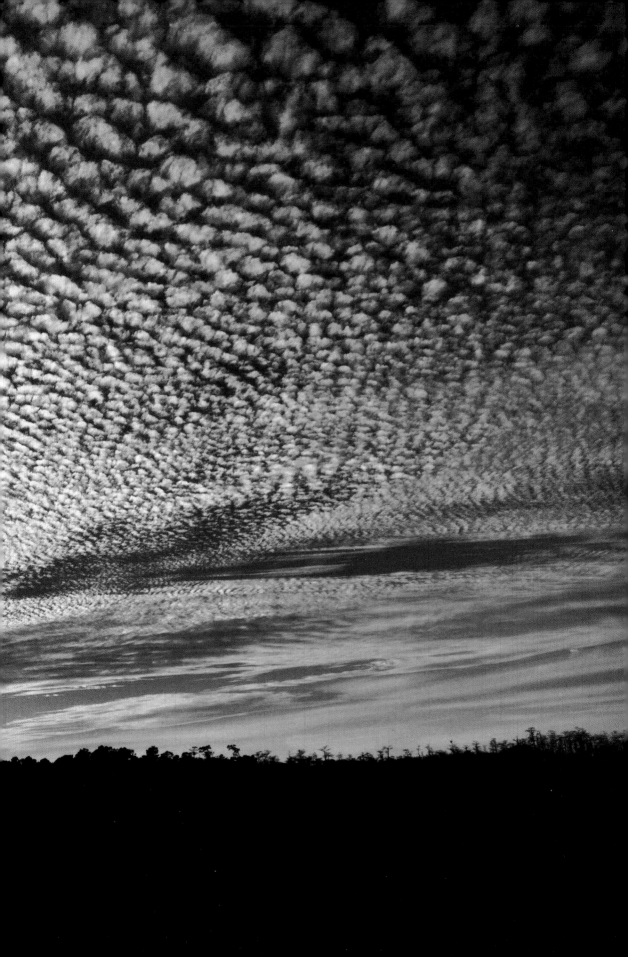

6. Into the Swamp

Clyde's life, and Ted's death, had brought him to the edge of wilderness. He had risen at dawn and driven until there were no roads left to drive. Then he shouldered the burden of the oversized camera and plates of unexposed film he carried in wooden boxes and left the world behind.

His hike had begun at a thick treeline tangled by trash holly, poison ivy, and thorn. To force himself through this pathless hedge was a leap of faith Clyde had learned to make without hesitation. The wiry limbs grabbed at his sleeves, the thick vines wrapped around his ankles. But after a few steps, he broke into the light of a broad wetlands, as undisturbed as it had been before white men had set foot on the continent, before any but the most ancient, unnamed wanderers had hunted here with stone-tipped spears.

Waiting for him on the other side was a tall, lean man wearing an off-white cowboy hat and homely horn-rimmed glasses. The man's

name was Oscar Thompson, Clyde's friend and his mentor in matters of the swamp.

Clyde had known Oscar for two years. They had met in Oscar's camera shop after the Butchers' move to Fort Myers. He was straight and lean; his long brown face looked like it ought to be wrapped around a harmonica and glowing in the dying coals of a campfire. Oscar looked his forty-plus years, until he moved. There was a fine, quiet grace to him, a youthful buoyancy in his body and even in his voice. Mixed with the slight cracker twang was a high tone never far from wonder or enthusiasm. Clyde had liked all of that, sensed they had some things in common, but Oscar remained just the guy in the camera shop, until one day Clyde mentioned how impressed he had been with Tom Gaskins' swamp. Oscar said nothing. He rummaged around behind a counter and came up with a box of color slides—all shots of the Big Cypress. "Wow," Clyde said, "I'd like to see where you got those."

"Let's go," Oscar said. He didn't mean sometime. He meant right that second.

In those innocent months before the accident, when Clyde's interest in the swamp was still casual, a hobby, like his early efforts in Yosemite, he and Oscar began to head out "to the woods," as Oscar called the wilderness to the east. Clyde found time whenever he could between traveling to art shows and maintaining his stock of California landscapes. Sometimes they went in Oscar's pickup, bouncing down the oil grades or slamming along the swamp buggy tracks in constant jeopardy of bogging down or just crushing a few vertebrae. Sometimes they went by boat into the mangrove maze of the Ten Thousand Islands. Sometimes, as they had that morning, they just left the truck on the side of the road and walked.

At first the relationship was built on Oscar's availability and enthusiasm. But it didn't take long for Clyde to realize that Oscar

had a special purchase on the place. Which was why Oscar was beside him now, why he was the one Clyde had chosen to help guide him more deeply into his grief, more deeply into the swamp.

Since Ted's death, Clyde's occasional excursions with Oscar had become daily odysseys. When Oscar had to tend to business in town, Clyde went alone. He had been at it intently for three months, slipping from the too-empty house before dawn while Niki slept, returning wet and dirty at night, too sore and drained to say anything. Niki knew Clyde was doing what he had to do. She made no complaint.

But Clyde's body did. His physical condition now nearly matched his psyche. Poised at the dawn of another day of slogging through wilderness, his back ached, his muscles cramped. Beside him, Oscar was almost perky, peering with barely concealed excitement through the treeline. Ahead, a browning prairie swept to the pale reach of horizon, interrupted only by towering islands of pine and summer-green stands of cypress hung with hulking white birds like forgotten Christmas ornaments. Oscar was not gazing at scenery but scanning methodically, first to the right, then quickly to the left, where a narrow spit of muck crossed out of the treeline into tall, tufted buzzard grass and palmetto. As quick as a deer trundling out of the brush, Oscar set off into the muck. "Double my tracks," he told Clyde across his shoulder.

Clyde inhaled deeply and stepped into the wet prairie. His sneakers, driven by the double burden of his bulk and the weight of equipment, sank and slid into the gray mud, which sucked at him but refused to hold. A caprock of limestone lay just below the muck, broken, jagged, and riddled with natural potholes just big enough to snare Clyde's feet, throwing him off balance, causing him to flail awkwardly to keep his camera above water. As he panted and swayed uncertainly, he could think of no more treacherous footing short of ice on a mountainside. But Oscar, toting only a 35-mm cam-

era, was in his element. He revealed no sign of effort, only concentration and euphoria as he churned powerfully ahead, eyes still scanning left and right as if looking for a trail.

There was no trail. As far as Clyde could tell, this was trackless wilderness. But in Oscar's eyes, it was more like a private backyard, the country of his childhood, the land his people had fought, sweated, starved, and bled over. For five generations, this was where they had borne children and buried them.

Clyde guessed Oscar was thinking about cottonmouths when he said to step in his footprints. Oscar instinctively knew which tufts of grass might harbor a nasty surprise—he'd spent a lifetime scanning his periphery for snakes and gators. But Clyde wanted to walk in Oscar's steps for a separate reason. He wanted to see the country at last from the inside out, not as a collection of trees and birds, grass and sky, but as a living presence, an overwhelming force of biological energy pouring into the world. There was no one better than Oscar to help him do that. If he could only keep up with him.

Oscar's bowlegged pace seemed to accelerate. The muck sprouted waist-high straw, then small myrtle trees and towering pines. Where the prairie grass grew thickest, the roots made a dry mat over the mud, and for a few steps it was like walking through a more familiar kind of pine forest. They saw animal tracks everywhere, the cloven hooves of wild hog, the almost cartoonish, stick-figured sign of wild turkey. Clyde saw scattered piles of bone and feather, the remains of a bobcat kill, and saw the shallow indentations in the tall grass where a doe had lain down to nap, and slightly larger depressions for bucks. Oscar halted. "Panther," he said in his high-pitched tone of wonder, pointing to a deep, wide imprint in the mud. "See how much bigger that is than the bobcat prints we saw earlier? And that's a juvenile. He'll get bigger yet, if he lives that long."

The morning wore toward noon. When they'd begun, they could still see the radio tower at the Oasis ranger station in the distance. Now they could turn slowly, 360 degrees, and see nothing that hinted of man. Clyde thought they had come a remarkable distance. But Oscar squinted, dissatisfied, into the sun already high above them. "We're really going to have to move if we want to get back before dark," he said.

They sloshed along a buggy track carved sixty years before by the chained tires of a Model A. Oscar called it a "road," but it was simply a rut of water too deep for grass to grow thickly. Then they cut off the track and followed a slight indentation in the prairie — cut by the passage of a large alligator. As they walked, the only human sound remaining was the metronomic splash of water parting around their shins and the thrash of their thighs cutting through rough-edged grass.

Clyde strained to match Oscar's pace, never quite succeeding. Oscar kept opening distance between them, then stopping impatiently, allowing Clyde to close the gap. Calf-deep in water, Clyde greedily sucked at his tepid canteen water while Oscar scooped crystal swamp water into his cupped, calloused hands and drank without concern. Clyde could feel his back stiffen as he rested. The muscles seized with pain. But when the spasm passed, he pushed on, leveraging his desire to continue against exhaustion. With every step in the swamp, Clyde cauterized his grief, his regret and rage, until at a certain point his mind would empty, the internal voices silent at last.

Clyde was fleeing not just from Ted's death but from a general unraveling of his family's lives somehow instigated by the accident. Clyde's father, who doted on his only grandson, fell into a sudden spiraling illness. He died just days after Ted. As the Butchers suffered through Clyde Sr.'s funeral, the sight of a chair beside them left vacant for Ted was nearly as terrible as the knock on the door only

two weeks before. The compounding grief had been more than Jackie could take. Her mind tried to block out the trauma behind a barrier of amnesia. She had not only lost most of her memories of her brother, but her keen sense of herself. Eventually, she quit school and came home, attempting to anesthetize herself with parties and drinking.

Only days after the double funerals of her son and father-in-law, Niki got word from California: Her own father had cancer. He would last only six months. As each fresh tragedy blurred into the others, the Butchers found no time for healing. Where should they start to grieve?

In the haze of getting from one day to the next, they were only peripherally aware that the wheels turned in the prosecution of the man who had instigated the deadly, drunken car chase that had taken their son. Summoned to court for a hearing, the Butchers saw for the first time burly, tattooed Dick Bush. Clyde was prepared to hate with an intensity he had never known. But the emotion never materialized. When he steeled himself and looked hard into the man's eyes he saw . . . nothing, neither remorse nor defiance, a lightless void. After that, he and Niki had no stomach for Bush's trial and they avoided the courthouse — there would be no solace for them there.

Or anywhere else. Through all the many difficulties of their lives together, there had been one constant: They had always had each other. Now even that failed them. The pain made them turn inward, too wounded to communicate. A doctor prescribed Valium for Niki, who only wanted to be numb. Clyde wouldn't take it, driven to find another way.

A few weeks after the funeral, friends urged Clyde and Niki to return to the show circuit and escape the daily reminders of loss in Fort Myers. Not knowing what else to do, they complied, loading the van and heading north. At the first show, in Ann Arbor, large crowds

kept them busy, mechanically going through the familiar motions. But at another show in Atlanta, the crowds stayed away, leaving Clyde and Niki interminable hours to think. Niki found herself scanning the mostly empty exhibitors' booths for tall, thin boys with curly hair. In each vivacious, young face she thought she saw Ted. She couldn't keep from looking.

Clyde was silent, beside her on a stool he'd used a thousand times. As the minutes dragged into hours, he realized the seat was no longer comfortable. The pictures on the walls of his booth looked unfamiliar to him, as if someone else had taken them for reasons he couldn't understand. He felt himself in free fall. The framework of his life, all the assumptions he had never questioned, slipped away. Then, as abruptly as it had come upon him, his vertigo vanished. In its place was a vision, a web of infinitely subtle form and variety. In a stroke, he knew exactly how to capture it all, exactly what to do for the rest of his life.

Clyde left the show. He walked into an Atlanta camera shop and wrote a $3,500 check for a two-and-a-quarter-inch camera and the black-and-white film to feed into it. He couldn't afford the camera. But later, he decided it wasn't enough and bought a larger one—an eight-by-ten-inch box camera and three used lenses. He collected one hundred fifty thousand dollars' worth of the color negatives and prints that had taken years to make and tossed them into a shed behind the house. His friends thought he'd hit bottom. At some level Clyde realized what he was doing could be considered a nervous breakdown, but that didn't concern him.

When he told Niki of his intentions, that he would photograph only natural Florida and only in black-and-white, he frightened her. Black-and-white pictures didn't sell, and no one wanted pictures of a swamp, even in color. Her own hand-colored photographs were selling better than ever, but it appeared that now her art would have to

be their sole support. She wasn't sure they would make it. But she could see Clyde was desperate.

When he returned to Fort Myers from Atlanta, Clyde's drift came to an end. He began his excursions with Oscar, and in just three months had made enough photographs to supplant the old color ones. His new pictures were haunting, primeval images of a Florida that bore no resemblance to any postcard or movie set, any landscaped city park or lush hotel beach. Somehow, the lack of color did not diminish them. It did the opposite. Instead of presenting a scene, the prints exuded a presence, a sense of the unifying force behind the million intricately related details — the force Clyde felt in the swamp.

When he hung the photographs for the first time, at a festival near Orlando, he was sure they wouldn't sell and didn't care. But he had miscalculated. Their power was contagious. His booth quickly filled with people staring wide-eyed, clustering around Clyde as if he were Ansel Adams. At the end of the day, he had blue ribbons for best in show, and two thousand dollars in sales.

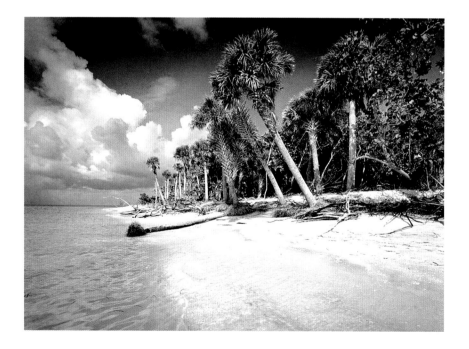

Clyde was shocked, not exultant. He had the feeling that he had somehow skipped a step, that he had only begun a long journey and people were treating him as if he'd arrived. Something was missing, and Clyde knew it. All he could think about was getting back to the swamp.

That brought him to this sweltering, midday moment with Oscar, knee-deep in water on the gator trail. Clyde soaked it in, exhausted, drained. He treasured this emptiness: absent talk, absent thought, absent malice. He was safe here. A moccasin coiled in the shallows was not a mindless destroyer, it was a hunter, contributing more than it took. Everything around him, from the thick mats of algae floating in the water to the vultures circling on thermals a thousand feet above them, fit together seamlessly, expanding, contracting, reacting to whatever extreme of storm or drought or fire, conspiring to maintain this place in timeless perfection. There was danger but not stupidity, rot but not waste. This was what Clyde was chasing with his camera, a world purified of human contact.

Clyde and Oscar were now miles from the nearest paved road, and, given that it was a weekday in summer, conceivably the nearest human. Ahead the swamp swept away forever, vast, enveloping, miles and miles of prairie and cypress strands like long, low hills in the distance, punctuated by scattered brush-stroke islands of palm trees. In all directions, the pattern repeated to the horizon.

Oscar had promised to lead them to an especially beautiful spot he knew. Oscar's ability to find a given square of swamp in this vast wilderness amazed Clyde. To the uninitiated, one cypress strand looks like any of a thousand others, one clump of cabbage palm indistinguishable in its relation to the surrounding prairie. But the swamp spoke to Oscar. Everything was a landmark: The rotting posts of L. B. Hart's old cattle fence that marked the way to the camp where Wilson Cypress, son of the Indian canoe maker Charlie Cypress,

once lived; the cabbage palm island Oscar had visited more than once when his swamp buggy was hopelessly mired in muck and he needed wood to wedge under the tires; the strand where he stood frozen in the dark listening to a panther bring down a deer.

In the middle of a wide prairie, Oscar came across a narrow rut in the wilderness. He turned into the light, his usually taciturn expression gone, his eyes beaming like a boy's. He raised his arms dramatically, animated with pride: "This," he said, standing knee-deep in the water, "is the Thompson-Pine Island road. This is the first road cut through this country by my grandfather, Sam Thompson."

Clyde had a moment of half-wondering if Oscar was playing games with him, seizing upon one small rut among dozens and claiming a fanciful history for it. But he soon discovered that Oscar's roots ran far deeper in the Big Cypress than he had imagined.

Oscar's great-great-grandfather, Captain Francis Ashbury Hendry, had battled Seminole Indians over this place. Oscar's great-grandfather, Waddy Thompson, had come to the Big Cypress at the end of the past century to continue the civilization process that men like Hendry had begun. He strung the first telegraph lines linking remote swamp towns with the rest of the world. In the process, he married Hendry's daughter, Laura. Their son, Sam, picked up where Waddy left off, transforming the old telegraph wires into phone lines. He also was one of southwest Florida's best-known hunting guides. Sam Thompson counted among his clients Henry Ford and Thomas Edison, men whose gifts of cheap cars and power would soon change the face of the exotic tropical frontier that had captured their imagination. Oscar's dad, named Waddy for his grandfather, also made a life introducing outsiders to the mysteries of the Big Cypress, guiding the rich and powerful men who followed Ford and Edison: the bankers, merchants, and developers using dredges and dynamite to reshape coastal Florida into a South Seas fantasy.

That was the upstanding, responsible side of Oscar's family. It had quite another side. His mother Laberta's family had not been civilization builders. They had been barely civilized. Destitute from successions of hurricanes and economic collapses, they never sought to tame the wilderness, merely to live in it, suffering the hardships of the western Everglades in the tradition of frontier pioneers. Laberta's father had been a notorious moonshiner, and her brothers, Peg and Totch Brown, were gator poachers, perhaps the Everglades' most successful, responsible for as many as thirty thousand slaughterings by spotlight and rifle from the bow of a tottering skiff. Peg eluded rangers and game wardens until his death in old age. Totch graduated to marijuana smuggling and earned more than a million dollars before his imprisonment at age sixty-two.

Oscar grew up somewhere between his divergent legacies—the civilization-building pioneers and the swamp-rat renegades. In Immokalee, he shared a classroom with Seminole Indian kids who still spoke Mikasuki and lived in traditional family compounds made of cypress poles and palm thatch, and who were more interested in hunting and fishing than in math and English. He became particularly close to a white boy named Billy, whose father had tried to scratch a living from raising cattle in the Big Cypress prairies. To the boys, the swamp was playground, schoolroom, and historical museum. Though his father taught him to obey laws, as a teenager Oscar took a page from Uncle Totch's book and began poaching alligators with Billy. They'd spend days wading knee-deep in swamp, poking long sticks into alligator caves, then dragging the thrashing beasts out with hooks. Even when shot neatly between the eyes, the gators would thrash for hours unless they were "rodded," which entailed slitting the gator at the base of the skull and inserting the long, stiff stem of a fern into the spinal column—like a ramrod—until the thrashing stopped and they were both covered with blood and

alligator slime. Then they'd skin their catch, salt the hides and roll them tight, stuffing dozens of them into sacks and loading down the trunk of Billy's car, driving all night to sell them, illegally, to a New Orleans wholesaler.

Though Oscar and Billy played cops-and-poachers with the Florida game officers, and tried to walk and talk like dangerous outlaws, both boys had a straight side. Billy went on to college and became a CPA. Oscar became a commercial photographer. His interest in photography began when one of the men in his father's hunting parties gave him a camera as a tip. Oscar knew what to do with it. His rough-hewn knowledge of the swamp had a lyrical side, a love for the sheer physical beauty of it. Every chance he got he walked into the swamp and tried to capture what he knew in his lens. Meanwhile he learned to support himself shooting images of food on the white-clothed tables of fancy restaurants and lean models smiling in Jacuzzis. By the time Clyde arrived in Fort Myers, Oscar had learned he could also sell his ever-increasing stock of wildlife and landscape photos to magazines and newspapers looking to illustrate stories on the vanishing natural Florida.

Oscar and Clyde had nothing in common but their love of cameras and swamp. It was the only bond they needed, but soon they would have another one. When Clyde told Oscar that Ted had been killed, the two men hugged and cried. Oscar came from a place where tragedies like that were ground deep into life. The Florida wilderness was a hard place where hard things happened. His Uncle Totch had watched, helplessly treading water, as his fishing boat burned with his two-year-old daughter in it. He had kept the vessel's Model A car engine going with string and baling wire because he couldn't afford to fix it right and couldn't afford not to fish. He saw the gasoline leak-

ing from a jury-rigged hose on the hot engine just before it blew him into the water. As he swam back toward the flaming wreck he heard the baby crying for him before she died.

Oscar knew there was nothing anybody could say to help a man in that kind of pain. But he also knew that by walking into the wilderness with Clyde, he was helping his friend heal. Clyde's grief was so big, this swamp was the only place he could make it fit.

By late afternoon on their hike, in the soft light of approaching dusk, clouds bubbled up from the distant strands to the west and streamed toward them. They had come to a cabbage-palm hammock, a stand of old, widely spaced trees with toothpick trunks and shaggy tops, palmetto bushes mimicking them at their feet.

"This could be interesting," Clyde said, in the language of understatement he and Oscar shared, unlatching the legs of the tripod. When the camera was assembled, facing west, the men waited. They didn't speak. They watched. The low clouds overtook them in stages, raining a depthless white mist and swallowing the sun

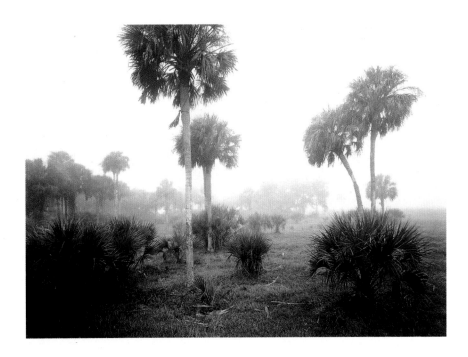

without extinguishing it. Clyde saw the light, diffused and glowing as if sourceless from all directions, transform the frail shapes of the palms into something from a wordless dream. He stood beside his camera and waited as the feeling built inside him, waited until he knew it was time.

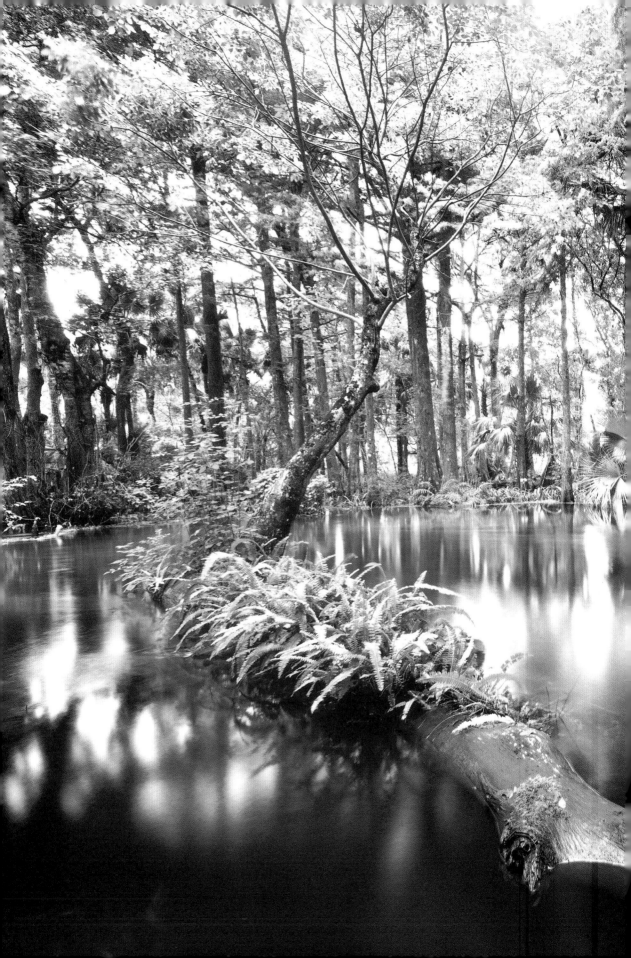

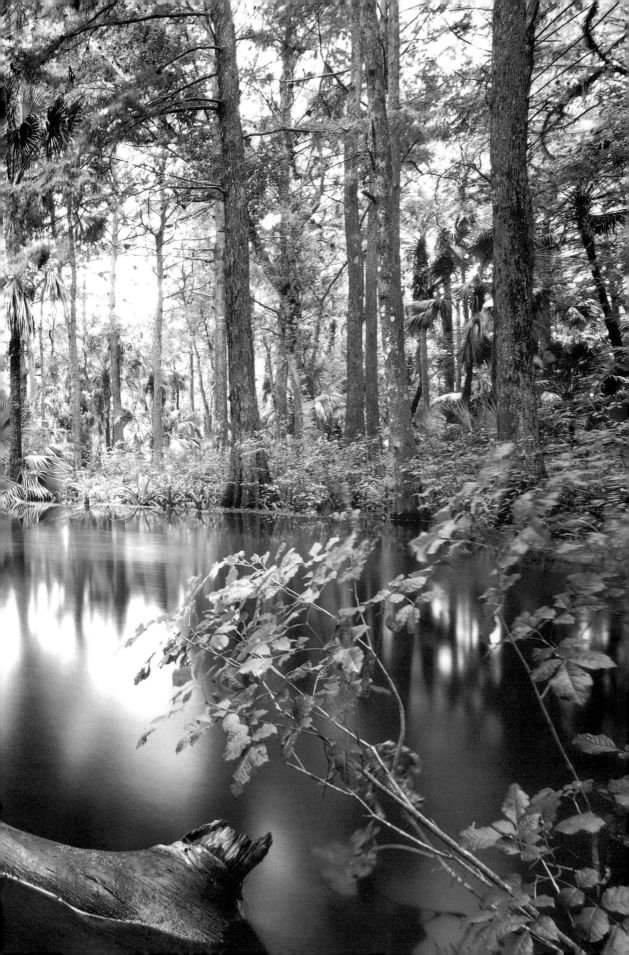

7. A Matter of Black-and-White

Each show was bigger than the last. It seemed that every time Clyde snapped the shutter on his camera, he made a photograph that surprised with its power, fascinated, made people want to buy it and bring it home so they wouldn't have to stop looking at it. More people flowed to Clyde's canvas-sided booth, more people bought his black-and-white photographs, more people lingered to talk to the big, bearded man in the straw hat—half Grizzly Adams, half Santa Claus. People who would never have dreamed of setting a polished Italian loafer in the swamp, whose eyes would glaze over if you tried to tell them about the beauty and importance of the Everglades, walked into Clyde's tent and said, "Wow. What state is this?"

In a way it was funny. The Everglades *was* south Florida, four million acres of swamp, marsh, and hammock bathed in an almost imperceptible current flowing 240 miles, from the Kissimmee River

headwaters near Orlando to Florida Bay and the Florida Keys. But two million acres of this ancient river had been stolen, drained, filled, farmed, built into cities and suburbs created in the image of everything from South Seas plantations to New England villages, everything but what it really was. To most people, the Everglades that remained were invisible. The portions that were visible were not true Everglades, but scars created by the roads and paths that provided public access, unbeautiful stands of invading junk trees, murky spoil canals, monocultures of whatever species thrive on disruption and pollution. The combination of inaccessibility and prejudice has kept the beauty Clyde portrays a secret for generations. Oddly, even some of those instrumental in founding Everglades National Park thought of it as biologically interesting but unsightly. In 1938, Daniel Beard, one of the founders of American Boy Scouts and a prominent naturalist, surveyed the area for the National Park Service and issued this report:

> The southern Florida wilderness scenery is a study in halftones, not bright, bold strokes of a full brush as is the case of most of our other national parks. There are no knife-edge mountains protruding up into the sky. There are no valleys of any kind. No glaciers exist, no gaudy canyons, no geysers, no mighty trees. Instead there are lonely distances, intricate and monotonous waterways, birds, sky and water. To put it crudely, there is nothing in the Everglades that will make Mr. Jonnie Q. Public suck in his breath . . . Whatever person or group of people are delegated to draw up a master plan for the Everglades Park will have to have full recognition of the drab character of the scenery.

Drab? Monotonous? The man must have been pricked by one merit badge too many. In Clyde's voyages with Oscar he'd encountered

breath-sucking beauty at every point of the compass, terrain that changed radically, not mile by mile, not from one mountain range to the next, but with each *inch* of elevation: from sun-dappled forests of giant, storybook cypress to vast sweeps of prairie. He'd seen crowned islands of snaking oaks, towering mahogany, giant ficus; clear currents flowing through tunnels of tangled mangrove; glassy streams coursing through buttonwood forests; gleaming stands of gumbo-limbo growing from the oyster middens of ancient Indians; shallow bays filled with the flapping wings of a million birds and the darting shadows of fish. The beauty was too stunning, too obvious for words. Finally, in Clyde's majestic prints, others saw that.

Clyde had taken the pictures instinctively, driven to capture a feeling in him. And now he saw what he had accomplished in thousands of stunned faces. Sitting high atop his deck chair as the heads swiveled and eyes popped, he tried to analyze what was happening.

He knew it had something to do with black-and-white. Black-and-white wasn't real. You can't look at a black-and-white photograph and simply think, That's what a swamp looks like. There's something missing. The viewer has to get involved, supply the missing element himself. Clyde decided it was like the difference between watching a movie and reading a book. A movie creates the illusion of a reality you can sit back and watch. A book makes you a participant in the author's reality.

But there was more. Clyde's reality drew people in, shocked them even. His images are viewed as if from inside the photograph, scanned from left to right, top to bottom, with new discoveries at every angle. This was the secret. In most photography, the entire composition is built on the fact that the human focal point spans only seven degrees, a mere spot at the center of vision. Most photography is reductive; it works because the photographer is able to screen out the clutter and dissonance of a scene and frame those seven "good" degrees.

In the Everglades there is no chaos or imperfection or mess. The entire compass flows together. Everything fits. Which is exactly why the swamp is so hard to photograph. Most pictures just reinforce the expectation that the Everglades are visually boring. Any single span of seven degrees encompasses only a clump of trees, a swath of grass—isolation doesn't make them more beautiful, it makes them seem bland.

But Clyde's favorite wide-angle lens and large-format camera produced a focal point of 116 degrees—more than twice as wide as a standard setup—a panorama too sweeping to absorb in a single glance, flawless in its detail. Every square centimeter was perfect, each blade of grass as sharply etched as the convolutions of a distant cloud, magic achieved with a combination of virtuosity and technique. Black-and-white film absorbs more information than color; large negatives many times more than the tiny postage stamps in 35-mm cameras. And Clyde closed the camera's lens to a pinhole so he could leave it open for minutes, rather than the infinitesimal blink of

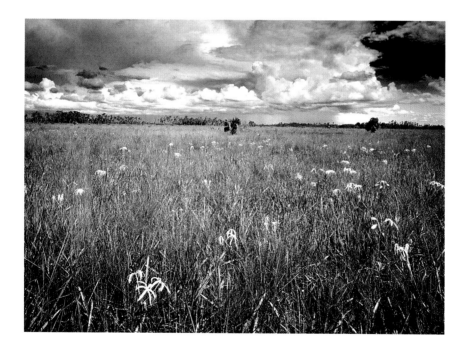

a standard camera in daylight. The slightest wind would blur the image, but the long exposure etched the image richly, and Clyde helped by bending the bellows of his box camera, tilting the lens so the plane of sharpest focus extended from extreme foreground to extreme background instead of vertically in a single plane. In Clyde's pictures, you could see forever.

Of course, none of that would have had such impact if the subject weren't pure. Clyde wouldn't take a picture if there was the thinnest remnant of a jet contrail in the sky or the faintest footprint in the mud. His photos were about a world without human impact, a world inexhaustible and eternal. That's why people thought his grandfather had taken them. They'd grown accustomed to a planet being worn down and used up, and the contrary notion had tremendous appeal. Overnight, Clyde became the star of the art circuit. He had no idea that, in a sense, his photographs were beautiful lies.

If you want to be considered a serious artist in the world of serious artists, you do not put your work in art festivals. Festivals are for pretenders, purveyors of schlock, *craftsmen*. Everybody who is anybody in the art world knows that.

Fortunately for Clyde, he knew nothing about the art world and cared less. Showing his work in festivals changed his life many times over, primarily because of the people who happened by his booth, then stopped dead.

Woody Wodraska found Clyde that way in West Palm Beach in the fall of 1987, more than a year after Clyde had dedicated himself to the Everglades. Wodraska was the director of the South Florida Water Management District, a giant state agency Clyde knew primarily as the keepers of the massive floodgates installed at various points in the canal system that snaked through the Everglades. But

"the District," as those in the know called it, did far more than raise and lower gates. The Water Management District was nearly as embedded in the history of south Florida as the Seminole and Miccosukee Indians, and of far more impact on its prospects for the future. Wodraska knew things about the swamp that even Oscar had never dreamed, things that, had he dreamed them, would have brought him awake in a cold sweat.

The forerunner to the Water Management District had been called the Everglades Drainage District. From the first day of Florida's statehood in 1848, the elimination of the Everglades was one of the chief goals of state government. The man who struck the first blow with his dredges blew his brains out afterward. Not because he regretted trying to destroy the Everglades, but because he failed. He didn't know it would take a half-century to accomplish the goal, and only then because the U.S. Army declared a war on swamps. The unlucky dreamer was named Hamilton Disston, a Pittsburgh plutocrat recruited to Florida by the governor himself and personally cheered by President Chester Arthur. Disston arrived in 1878 with a million dollars to buy rights to much of Florida's interior and a dream of draining the Everglades to create an agricultural empire out of the drying muck of five thousand years. Disston was an immediate sensation, praised by newspapers and forward-thinking Americans everywhere. But although his dredges chugged through the swamps for fifteen years, the Everglades stayed wet and his companies went bust. So he drew a bath one evening, lay in the warm water, and shot himself in the head. Florida Governor Napoleon Bonaparte Broward took up where Disston left off in the early 1900s and presided over four major canal projects. But those canals failed, too. They overdrained in dry seasons and failed to prevent flooding in wet years.

The state really got serious about drainage in 1928, when a great hurricane blew over Lake Okeechobee. As the storm moved north, it

piled massive amounts of water against the lake's north shore; then as the winds turned, a wall of water hurtled back south, sweeping over the southern shore and the town of Belle Glade, killing two thousand people. Photos of giant plumes of black smoke from burning pyres of bodies were carried in newspapers across the country. Public outrage demanded the harnessing of the lake's destructive potential and resulted in the construction of the Herbert Hoover Dike, which dammed the lake's south shore. But they had not yet dammed the Everglades, and twenty years later torrential rains sent floodwaters surging as far south as Miami, inundating Pompano Beach, Fort Lauderdale, and the Miami airport. Something had to be done about these horrible, four-million-acre swamps, and so the country turned to the outfit whose motto is "can do"—the Army Corps of Engineers. It took the corps nearly twenty years beginning in 1948, but when it was done, the wild, unconquerable Everglades were tamed—not just tamed, but broken. The corps dug a thousand miles of canals; it put in pumps capable of moving thousands of cubic feet of water per second; it diked the east coast cities from the lake to Miami; it segregated the northern Everglades into a series of massive and diked impoundments called water conservation areas, serving as reservoirs for cities; it made possible huge new areas for farming and development; it brought the suburbs to the edge of the levees. It permitted the construction of rock pits, airports, shopping malls, golf courses, warehouses, and thousands of acres of sugar plantations where once there had been nothing but water, saw grass, and forest. The corps could do and did everything that had been asked. And then it all

began to go terribly wrong.

The problem was as simple as a total misunderstanding. The Everglades had been attacked as if they had been a pool of fetid, standing water in someone's backyard instead of what they were: a vast shallow river that had, over a geologic age, become a unique engine of life, the liquid heart of a subtropical paradise on the tip of

North America. Everything special about south Florida, its crystal waters, plentiful fish, majestic birds, unquenchable wildlife—even its alluring climate—had been created on this foundation of rain, rock, and sun.

Like any river, no given acre of Everglades existed independently. Everything flowed together, from the headwaters north of Lake Okeechobee to the estuarine mangrove maze of the Ten Thousand Islands and Florida Bay. The corps's main accomplishment had been to drain half a million acres just south of the lake, claiming for agriculture the rich soil created by thousands of years of growth and decay of swamp plants. With one chop, the Everglades had been decapitated, the three million acres to the south forever separated from the headwaters that fed them. Just as one agency of the federal government was establishing Everglades National Park to preserve the swamp in its natural state for all time, another was working day and night to doom it.

This contradiction escaped all but an unheeded few for two decades. It was only as the corps's project neared completion in the late sixties that people began to worry that things had gone too far, and that Everglades National Park might die of thirst. In the 1830s, army scouts reported that they could float a canoe across the state even in the dry season. Now, that was often impossible, even after months of summer rains. The wading birds that once darkened the sky by the millions had become scarce. Alligators were in danger of extinction, and the lack of the holes gators thrashed out of the muck meant there were no wells to hold the retreating water in the dry season, and fewer and fewer places for fish to breed and birds to feed on the fish.

Acknowledging the problem, but still blind to its complexity, the corps considered it a simple question of "water delivery." Wet season or dry, the corps guaranteed the park would receive a monthly

minimum of water flushed through their canal gates as if they were yanking periodically on a toilet cord. Thus began the tragicomic procession of well-intentioned people trying, with absurdly crude strokes, to repair the damage man had done to the land. It was like trying to reassemble a smashed Rodin masterpiece with Silly Putty and glue. The would-be water managers had failed to observe that there was reason in the Everglades' cycle of wet and dry. Dumping monthly amounts of water into the park without regard to season was more damaging than the original dehydration. Wading birds depended on the dry season for a habitat to build nests, and dwindling water holes to concentrate their prey. With the water flowing all year round, the birds stopped reproducing altogether. The not-too-wet, not-too-dry water delivery schedule transformed other areas into upland forest, which caused explosive increases in the deer population. Then, when years of unusually heavy rains came, the deer drowned by the hundreds. It went on and on, a cycle of destruction and reaction as the degradation compounded and multiplied. The sudden inundations of water from the floodgates bore no resemblance to the slow rise and fall the Everglades required. The alternating shocks of too much water and too little pounded on the delicate estuaries of Florida Bay, short-circuiting the finely tuned interplay between fresh and salt waters that had made it one of the richest marine nurseries in the world. The sea grass once visible blade by waving blade through six feet of water died off by the acre, the transparent water clouded with pea-soup blooms of algae; the fish that once flitted before boats in boggling swarms vanished from giant swaths of bay the scientists began to refer to as "dead zones."

As the estuary choked on too much of a bad thing, the swamp was being strangled by its own malignancy, imported from Australia—a fast-growing, water-loving tree called the melaleuca, whose seeds had once been sprinkled from airplanes in the hope that thirsty

91

roots would dehydrate the swamp, as if dense, characterless forests capable of harboring no undergrowth or animal life in the ingrown press of peeling, papery trunks was an improvement. In the absence of the Australian pests that keep the trees in check, the melaleuca increased geometrically. The tree seemed nearly indestructible. Drought made it drop seed. Its resins burned hot as gasoline in fire, but the heat merely made the tree explode, blasting an airborne invasion of seed into new territory. Storms had the same effect. Melaleuca's only grace is that it is not deadly poison, as is the organic mercury from uncertain sources that had somehow intruded upon the Everglades food chain, threatening what birds remained and rendering fish unsafe to eat.

On the north end, Lake Okeechobee itself began to die, infected with massive, rotten-egg-smelling algae blooms caused by sugar farmers back-pumping their nutrient-rich wastewaters into the lake, and the rainwash of manure from the dairy farms on the northern shore. Any bass fisherman or tourist could see the once-beautiful waters turn turgid and the fish wash up stinking on the beaches. Desperate to prevent a final collapse, water managers restricted the dairy farms and began pumping the sugarfield wastes south, into the swamps. As the dirty water flowed into the pristine clarity of the saw grass marshes, it was as if a switch had been thrown. The purity of the Everglades was the result of harshness, a near sterility of the environment. Its flat rock surface—forever washed by the current of taintless rainwater, innocent of the sediments from eroding hills or mountains—was one of the cleanest places on earth, a place where the first living things found plenty of light and oxygen, but precious little else to nourish them. To learn to thrive there, an organism had to be highly adapted, intricately connected to all possible resources, interwoven with the growing web of life finding a purchase on the face of the rock. From sparseness arose a bewildering variety. Under

such austere conditions, it was impossible for any one species to dominate, to exist without dependence on a thousand other forms whose presence both threatened and abetted.

There was no spot in the world where the enriched soup of farm runoff could do more damage. As soon as the nutrient-laden water flowed into the marsh, the oxygen-loving bacteria at the base of the living pyramid shut down, supplanted by forms that sucked life not from pure oxygen but from the dirty water. The gaseous by-products of this new dominant group made the marsh smell for the first time of death and decay rather than life and growth. The occasional stands of cattails—previously found in concentration only downstream of bird rookeries, opportunistically clinging to the plume of decaying feces and flesh—were suddenly unleashed, blooming everywhere until the variegated sparse meadows of saw grass and pond lily and dozens of other flowering plants were transformed into dense fortress monocultures. The cattails grew too thick to penetrate, too thick for fish to swim or birds to light, too thick for anything but mosquitoes to breed. In short, it transformed the rare wilderness into just what people had so falsely assumed it was to begin with, a fetid, smelly, mosquito-generating wasteland.

When Wodraska happened on Clyde's booth in West Palm, dealing with the death spiral of the Everglades was only part of his agency's problem. Getting the public to care about it was another. He saw in Clyde's work the answer to the billion-dollar question: Is this worth saving? Specifically, Wodraska was trying to build support for the purchase of large tracts of private land that bordered on the still-wild streams that flowed out of the Everglades. He asked Clyde if he would be willing to document the beauty of the lands. He talked about hanging Clyde's work in the district's lobby, using it for posters. He talked about how important it would be for educating the public. He didn't talk about money. There was none. Clyde accepted.

For two years Clyde traveled to the state's most sensitive wilderness areas to make pictures, and for the first time it dawned on him that he was doing more than capturing their beauty. As the bureaucrats and scientists explained why they needed him, Clyde absorbed the bad news, soon understanding he was documenting places that were in grave peril and might someday no longer exist.

That was a concept. As Clyde floated down the cool, slow current of rivers dark with ancient shadow, the still-invisible threat irradiated his heart. He swam, immersed to his neck beside the canoe carrying his camera equipment. He had discovered that being physically part of the scene, literally immersed in it rather than simply passing through, made images leap out at him one after the other. It made him feel connected, rooted to the spot like one of the hundred-foot-tall cypress trees. As the hours passed, the murmurings of his mind quieted and the sounds all around him amplified, water and wind and wings, until the air itself seemed to buzz. Photographs composed themselves before his eyes; he saw them complete, knew

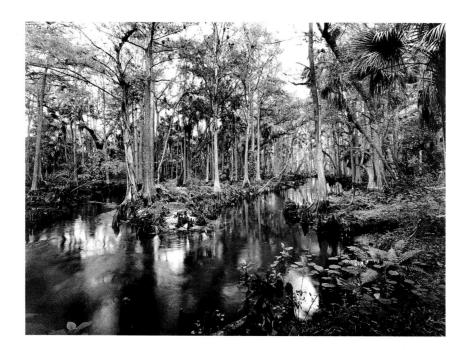

the exposure time, the f-stop, the filter before he even reached for the camera. Even as he worked, the stillness in his mind did not diminish. Something ancient in him was nourished by this. He fit here like he fit nowhere else. Whatever power it was that buzzed in thin air and made perfect pictures appear like magic had also made *him*, of that he was sure. He felt the kind of awe he had felt looking out at the night sky from the deck of his boat in the middle of the dark ocean. But he could not wade in the deeps of space, brush against the stars. Here it was as if he could touch the eternal, a place that had been remaking itself ever since the ocean rolled back and sun shone on the reef.

Only, Clyde knew now that it might be closer to terminal than eternal, and the knowledge hurt him, drove him again and again into the dark shroud of his camera cowl to save what he could before it was gone, to make people see what they were destroying when they still might have a chance to save it.

Clyde didn't like to say it aloud, even to himself, but the possibility that God had chosen him was never far below the surface. How else to explain the bitter waste of his son, the sudden certainty that he had to change his life, the swift and astounding response? He had been unable to go into court and rail against the wastrels whose deadly carelessness had killed Ted. Now, through the viewfinder of his camera, he railed against the global carelessness that was threatening to kill the wilderness.

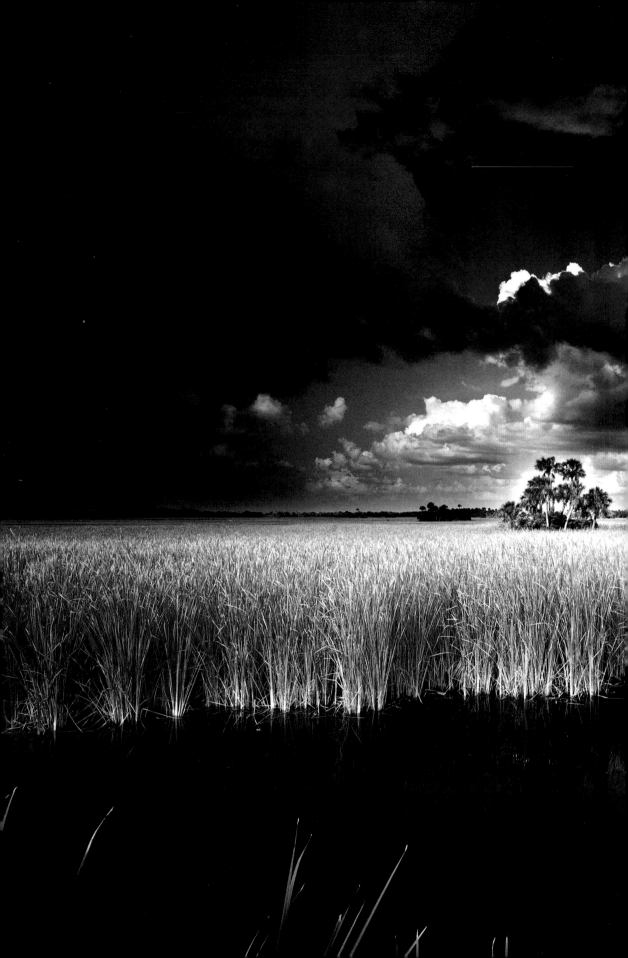

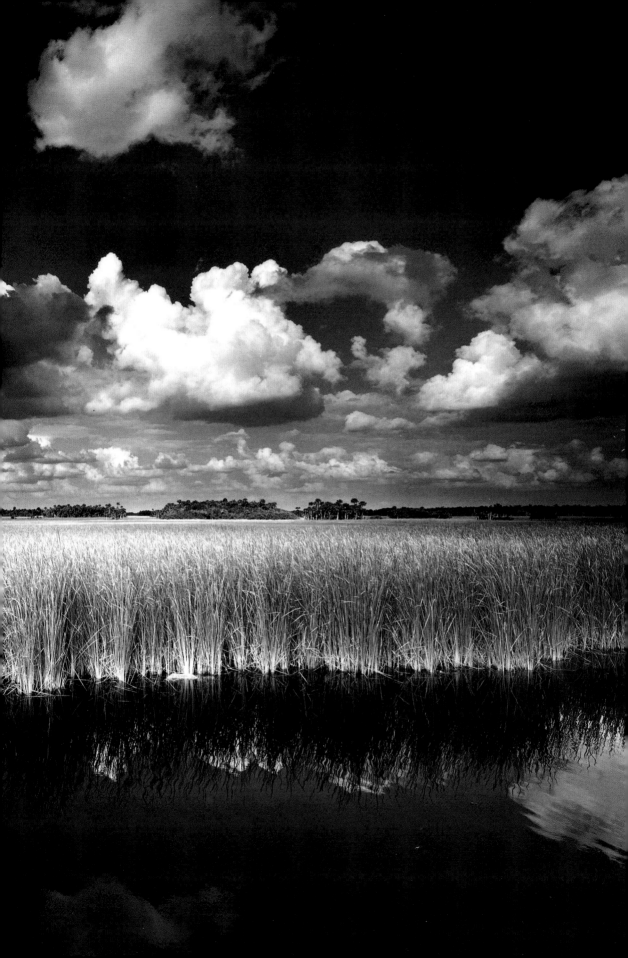

The miracle of the light pours over the green and brown expanse of sawgrass and of water, shining and slow moving below, the grass and water that is the meaning and central fact of the Everglades of Florida.

It is a river of grass.

— *The River of Grass,*
Marjory Stoneman Douglas

Waist-deep in the swamp, head-high in grass is a surprisingly pleasant way to spend a south Florida summer afternoon. The water cools both body and air, a bubble of vaporous protection against the toxic intensity of the tropic sun. The mosquitoes, ferocious beyond belief in the shadow of any hammock, are beaten back by an alliance of prairie wind, hot sun, and a multitude of tiny gambusia minnows called mosquito fish for their preferred cuisine. When the thunderheads boil up, as they do almost every summer day, black anvils flashing malignantly in the distance, the heat drains from the air, sucked into the gathering power. There is an electric moment of cool and quiet. The sharp light of the sun still etches the east with a clarity made poignant by the approaching night of storm. The wind quickens, the clouds swell, the inky torrents drop like a curtain.

Clyde caught that moment, magnificent and foreboding, the very first time he clicked the shutter of his eight-by-ten. About a

month after Ted's death, he and Oscar had hustled the new camera out to a place Clyde knew near Ochopee, accessible from the highway. He had noticed the spot many times before for its dramatic sweep of prairie, the "river of grass" Marjory Stoneman Douglas had rendered into poetry forty years before. The heat radiated up from the highway. Clyde could feel the hot breath of the cars and trucks as he climbed up on the guardrail to set the camera high. But under the cowl, the world of melting tar and exhaust vanished. There on the viewfinder a dark line of water shimmered before the mass of wheat-like stalks stretching to infinity in the sunlight. Above, a storm swept in, herding a flock of fleecy clouds before it. Dead center, between grass and sky, storm and sun, a graceful cluster of palms rose, a perfect island of calm. Printed dark on white paper, you can't take your eyes off it.

Clyde thought it a somewhat miraculous turn of events that the first negative he exposed after his Atlanta revelation became his most popular print. Four years after he made the picture, with Clyde becoming an icon among Everglades conservationists, his "River of Grass" picture was the natural choice for Marjory Stoneman Douglas's 101st birthday present. Douglas, whose remarkable passion helped create the American ecology movement and nurture it through three generations, loved the photograph, and so did all the environmentalists and state officials who had gathered to pay her tribute. Not one of these people who had spent so much of themselves thinking, talking, and fighting for the Everglades noticed the single most significant detail in Clyde's photograph.

The River of Grass was not what it seemed. The idyllic prairie no longer contained a blade of saw grass. It was a thick stand of cattails gone crazy in the polluted water draining from the farms of Immokalee. What seemed at a glance to represent the pristine beauty of the place in fact represented its coming demise.

A year after the print was given to Marjory, the Wilderness Society compounded the irony by choosing the River of Grass picture for a conservation award presented to Florida's feisty director of the Department of Environmental Regulation, Carol Browner, the woman destined to become Bill Clinton's choice to sit in his cabinet as the director of the U.S. Environmental Protection Agency.

By then, Clyde had realized his mistake. He asked Browner, "When you look at this picture, do you see any problem?" She wasn't sure what he was getting at. "It's absolutely beautiful," she said.

"Not absolutely," Clyde said. "This stuff in the foreground isn't supposed to be there. Your job is to get rid of that. It's a reminder on your wall."

For a time, Clyde thought about taking the negative out of his files, never making another copy. But he decided it was a reminder to him as well. It wasn't enough to look at the Everglades as a photographer. He had to know it as an intimate, to feel it as a living reality. In his increasing contact with environmentalists, Clyde had noticed that for many, their understanding of the Everglades was all theoretical. A surprising number had never wet their feet in the swamp. Even Marjory had admitted in her autobiography that she was more fond of the *idea* of the Everglades than the actual fact of it.

Clyde couldn't afford the luxury of an arm's-length approach. He had learned that at Yosemite. After ten years of trying to photograph the park's wonders, Clyde compared his portfolio with Ansel Adams's work. The difference leapt out at him: Adams lived in Yosemite. He was photographing his life. Clyde knew he couldn't duplicate that. To do so, he would have to know that on a certain day the sun comes between two particular mountains, to have seen that many times, to be there on the one morning when everything else was perfect, and to be there on every other morning until he came to understand the light, the weather, the way it all fit together. You had

to wake up in the morning, look out the window, and say, "Those clouds are heading down to Corkscrew Swamp, I bet that's going to be interesting." Or step out the front door and realize that there was no time for breakfast because the temperature was just right for fog.

If Clyde only wanted to take pretty pictures, he could drive out to the Southwest and snap dramatic shots of mesas and canyons. But Clyde no longer had interest in making pretty pictures of the Southwest, or even of the Everglades. He wanted to photograph the swamp's soul. And he knew he had to live there to do it.

That was a problem. Who lived in the Everglades? Indians, mostly. The whole area was either a state or federal preserve. He couldn't just go out there and buy a piece of land. And Clyde needed more than a piece of land. He needed a place where he could build a home and a gallery, a place that looked like the scenes in his photographs and happened to be on a highway that would bring a steady stream of customers. And one other thing: It all had to come with a small price tag.

Obviously, no place like that could exist.

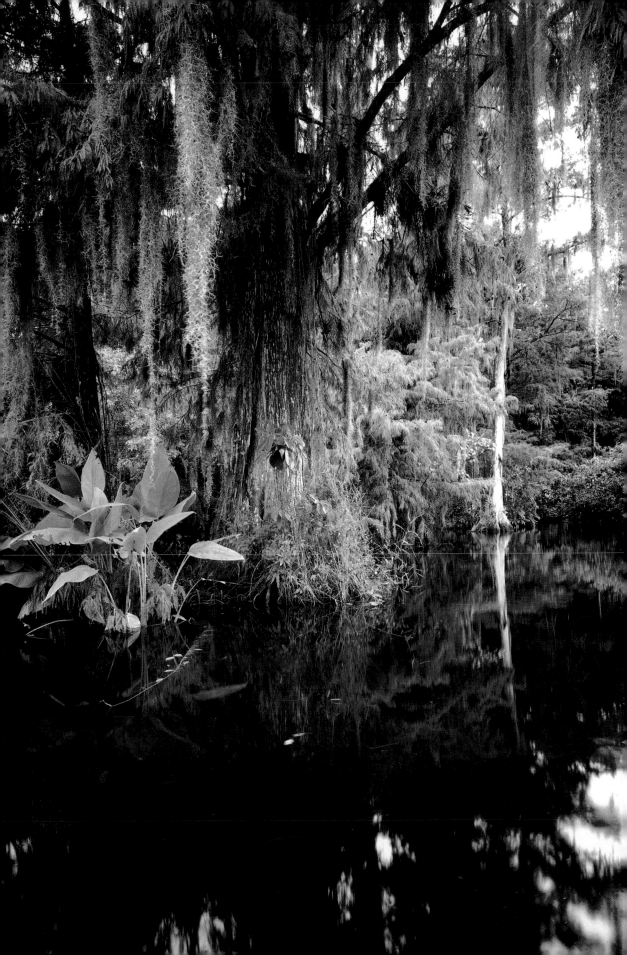

In nearly all the untamed and unfenced three-quarter-million acres of the Big Cypress National Preserve, one small, soggy plot was off limits to Clyde's cameras. He had tried to photograph there twice. Each time he had to grab his cameras and run for his truck from a thick-waisted, bald-headed octogenarian waving a machete and a small, snarling poodle. Clyde spun the tires making his getaway, grinning foolishly, feeling like a twelve-year-old caught filching apples. He had grown wary of cottonmouths and gators in the Big Cypress, but this was his first encounter with a snapping swamp poodle. As he drove off, the clear cypress pond, lighted by slashes of tropical reds and purples, faded into the jungle green of Tamiami Trail. Clyde hated giving up. He could make great photographs there if he could get past the old man and his little dog.

A sign on the property, ORCHID ISLES, and a shack by the pond suggested another tourist trap, but after his revelation at Tom Gas-

kins' Cypress Knee Museum, Clyde had more respect for such establishments and their possibilities. He hoped to impress Niki with his own discovery of a swamp Eden, and even from the road he could see he had found one. Old-growth cypress surrounded the pond. Bromeliads, orchids, and other brightly colored, flowering air plants dangled from tree limbs like party balloons.

The place was in fact a tourist trap, with one difference: The owner hated tourists. Vacationers crossing Tamiami Trail between Miami and Naples, their backseats full of children with brimming bladders, mistook the Orchid Isles sign as a beacon of welcome. They piled out of cars to see the flowering blooms, only to find the bald-headed elderly man and his bristling poodle posted sentry behind the upper half of the shack's swinging door. If something about the visitors irritated the old man — New York plates and perky, precocious children were among the risk factors — he'd simply growl, "I'm not here."

Clyde, usually muck-coated and mosquito-bitten, hardly looked like a tourist, but unwittingly made himself persona non grata because of his beard. For several years, the old man had affected a hermit's appearance, letting his gray whiskers grow long and scraggly, but in the 1970s, beards became fashionable, compelling him to shave his face — and skull for good measure. He then banned another category of visitor: the unshaven.

After Clyde's two strikeouts, Niki next tried winning admission. She was curious about the gruff eccentric and his garden of orchids, and every story Clyde told her about machetes and snapping swamp poodles only made her want to see the place more. On Everglades expeditions with Clyde, she had glimpsed other swamp denizens — clans of Miccosukee, settlers, and fish-camp operators, stubborn, solitary squatters — and she admired their self-sufficiency and disdain for conformity. She wished she could stray that far.

It was what made the Big Cypress special to the Butchers. The vast prairie of cypress, sedge, grass, and pine islands is a national preserve, not a national park, and its inhabitants, besides alligators, ospreys, and panthers, include several hundred people. Sandwiched between the northwest edge of Everglades National Park and the Big Cypress Seminole Indian Reservation, it has a human component much different from the Everglades park. There, Indian campsites and pioneer homesteads were closed down and burned— sometimes ruthlessly—decades ago. But despite a human presence in the Big Cypress, its waters are cleaner and its biology more robust than in the troubled eastern Everglades, where a metropolis of two million people lies just a fence wire away from the diked wetlands. The Big Cypress has long suffered the excesses of overhunting, careless fires, plowed prairies, and imported exotic pests. But its headwaters had not been destroyed, at least to the extent that the Army Corps of Engineers had diked and channeled the eastern Everglades. Because of relatively low-scale farming and development, Big Cypress Swamp water remains nearly pure. Hunters and hikers like Oscar Thompson drink it straight, concerned more about deer feces parts per billion than mercury or phosphate. And the human accommodation was important to Clyde and Niki, bolstering their hope that they could become part of the wilderness without destroying it.

One afternoon Niki drove to Orchid Isles alone. She got out of her car slowly, holding two dollar-bills high so the old man could see them. He let her through. She had caught him in a talkative mood on a lonely day, and he agreed to give a tour and tell the history of the place. Even the tiny poodle trotted amiably alongside. As they strolled along a path festooned by a thousand gloriously shaded orchids, into a naturally canopied sanctuary surrounded by cypress swamp, she listened politely. But she had been secretly distracted by something else she saw by the pond—a FOR SALE sign.

The little dog's name was Grumpy. The man's name was Louis Napoleon "Leon" Whilden, Jr., born eighty-four years earlier to the son of the United States ambassador to Denmark. He grew up in Copenhagen, attended the best schools, became an engineer, and moved to Miami in 1945 to work for the Curtiss-Wright Corporation, a pioneering aviation company. After just four years, he quit and retreated to the swamps in self-exile. Whilden simply couldn't fit in and was sick of trying. But even in the Big Cypress Swamp, his contrary nature posed problems. He made his living selling orchids, but he often changed his mind in the middle of a sale and canceled the transaction, telling his confused customer that orchids were too difficult to keep alive and buying his was a waste of money. When his own family came to visit, Whilden tolerated an hour or so of after-dinner small talk, then abruptly announced, "Good night, I'm going to bed." That was their signal to leave.

In later years, his only daily companion was a drifter named William Akers, allowed by Whilden to live on his cypress isle under a form of indentured servitude—work, but no pay. Not much work got done. Both drank heavily and brawled bitterly, and Akers bore an ugly welt on his shin from Whilden's machete. After one bloody quarrel, Whilden called the police to arrest Akers. But instead an officer bawled furiously at Whilden, "Leon, if I've told you once, I've told you a thousand times, you cannot go around hitting people with machetes." Stories about him spread up and down Tamiami Trail, and he cultivated his reputation as a character. A visit to Orchid Isles became an unofficial initiation rite for new rangers in the Big Cypress. Whilden led each recruit down his primrose paths, all the while feigning a stiffness in his arm and complaining of a nerve disorder. As his afflicted limb swung back and forth, his hand rapped the astonished rookie's genitals.

But his need for solitude conflicted with his yearning for a connection with life. One night, the Hermit of Orchid Isles made a call

to the ranger station's radio dispatcher. "This is Louis Napoleon Whilden, Jr.," he said. "It's my eightieth birthday. I just wanted to tell somebody."

As Whilden told Niki his story she could barely manage to breathe. She stepped carefully, afraid that any sudden motion or change of expression would somehow make that FOR SALE sign disappear. It was too perfect, of course: one of the most stunning corners of swamp she had ever seen, on a main road to Everglades National Park. Finally she asked him about it, prepared for the mirage to pop like a soap bubble. But as soon as the words passed her lips the old man unburdened himself. He wanted out. The place was falling down around him, he said; exotics had spread out of control, consuming his paradise. Even his beloved orchids suffered from his inability to keep up. He would sell the place in a minute—to anyone but the government. The National Park Service had tried to run him out once, hoping to condemn Orchid Isles and add it to the preserve, but he had fought the feds off in court. Now all he wanted from any private buyer was $85,000. Niki spun tires leaving Orchid Isles, just as Clyde had. She hurried to bring Clyde back.

By Big Cypress standards, the Butchers were the strange ones. Clyde looked the part of a swamp man, but he was not—not yet. As Southern Californians who once made Penney's wall decor, he and Niki represented gentrification of a neighborhood that—long before environmentalists cared about it—was home to misfits and desperadoes. One time, the woods were full of them—losers and loners, outcasts and outlaws—taking refuge on hidden lakes, mangrove islands, and shell mounds. Probably the most infamous was Edward J. Watson, who migrated from the Wild West to the western Everglades after gaining a reputation, justified or not, for gunning down the outlaw Belle Starr. Watson was himself shot dead by vigilante home-

steaders in 1910, after the corpses of his associates began washing up on Chokoloskee with chains around their necks. The names of local landmarks told such refugees everything about the country they needed to know: Buzzard Key, Hell's Half Acre, Lostman's River. If they went in, no one would follow or find them—at least until the National Park Service transformed the Everglades into a tourist attraction.

Then even the hermits turned up on sightseeing itineraries, next to the manatees and ibis. One was the Hermit of Posseum Key, Arthur Leslie Darwin, who came to Lostman's River in 1935 to trap but stayed long after the hunting played out, riding out Hurricane Donna in 1960—his fifth big blow—at age ninety-five. Ten years later, Hermit Darwin was displayed in a carnival booth at Everglades City, and people paid twenty-five cents to chat with him for three minutes. Darwin endured on Posseum Key until his death in 1977, at age 112. The old trapper's nearest neighbor was the Hermit of Pelican Key, Roy Ozner, a writer and painter, who fled to the wild in 1950 to escape a booze addiction. So congenial a hermit was Ozner that his isle became a scheduled stop for sightseeing boats. He was interviewed by David Brinkley and visited by Gypsy Rose Lee during the production of "Wind Across the Everglades." Afterward, Ozner proudly hung a sign on his bunk: GYPSY ROSE LEE SLEPT HERE. He was seventy years old when he died beneath the sign in 1969.

Hardy as hermit crabs, most of these swamp dwellers carried their houses on their backs. They achieved spiritual intimacy with the land, became its rightful inhabitants as much as panther or gator. But they also abided by a truth about Eden: The beauty masks a hard place. The life is stunningly diverse but sparse. Food is hard to come by, requiring strength, cunning, and luck to acquire. Conditions change drastically from season to season, year to year. The landscape is altered regularly by wind, flame, and flood, feeding patterns dis-

rupted, nests destroyed. Creatures survive however they can, by tooth, fang, stinger, and claw. The strong don't flinch; the weak don't last.

Clyde and Niki—given a glimpse into this rarefied world by Oscar Thompson—were eager for a closer attachment to swamp dwellers and their way of life. But the more the Butchers learned, the more they saw the risks. The experiences of others who sought to test the swamps weren't the sort to inspire visions of Eden. They were nearly the opposite—struggles raw and rugged enough to give even Clyde pause.

One such Orchid Isles neighbor was known to the IRS as Mrs. Clara McKay, but her considerable renown in the swamps was by another name: Hokie Lightfoot, the Beerworm Lady. Hokie was the daughter of a Georgia Cherokee sharecropper named Rufus Lightfoot. She married a childhood neighbor named Tony McKay and moved to Miami, where she worked as a store clerk and Tony as a plasterer. When a life of hard work and too much booze began to take a toll on Tony's health, the couple bought five swampy acres with their meager life savings and opened a bait-and-tackle camp. Hokie fashioned the sign herself on a cypress board and tacked it to the bridge over their canal: BEERWORMS. The sign has been there forty years.

The McKays' closest neighbors were a Miccosukee Indian clan. Miccosukee men would stop on their way home in the evenings to drink cold Budweisers. Hokie and her husband were the kind of neighbors the Indians appreciated—quiet, noninterfering people who abided by the Golden Rule of Everglades residency: Mind your own business. A distant yet respectful relationship developed between the clan and the McKays. And later, when Tony McKay's heart weakened so severely he could no longer walk, the Miccosukee arrived one evening in early summer with a truck and stretcher. They carted him to their Green Corn Dance, a secret festival few white

men had ever attended, hoping their medicine might heal him. But nothing would save McKay. He died a few months after the dance, in Hokie's arms.

She stayed on, cultivating her worm beds, selling her Budweisers, for four decades, into old age — until the fateful moment of her life when the Everglades revealed its brutal side in perfect clarity. Late on a fall afternoon, her little Pekingese began to yap and she went to the canal bridge to draw water for him. As she leaned over, a seven-foot alligator quickly scuttled from beneath the bridge and bit into her right arm, just below the elbow. He pulled her flat on her stomach. Then, for a long moment, they lay connected, frozen in a stalemate. Hokie, eighty-one years old, gently swatted the gator on his nose, talking softly to him. "Please let me go. Don't kill me." The gator held tight. Then the gator simply rolled over. As he did, her arm below the elbow snapped like a dry stick. She lay on the bridge, the gator floating below, her splintered forearm clenched in his monstrous jaws, fingers protruding from his teeth. She calmly waited for death, praying for God's deliverance. But an internal voice spoke to her: *Go in the house. Get up and go in the house and dial 911.* "I can't," she protested. "I'm hurt. I'm tired. Let me die." But the voice persisted: *Go dial 911.* She pulled herself to her feet and stumbled deliriously in the twilight toward the house. She got to the phone. Her hand shook. She dialed 611. The voice was patient, firm. Hokie, it said, you have to dial it again: 911. This time, she dialed correctly, then walked back outside, seating herself under her chickee until an ambulance arrived. A game warden shot the gator on the spot.

Gators were about the only swamp creatures that had never attacked another of Orchid Isle's neighbors, Midge Lessor, a fifty-seven-year-old woman who had been trying to breed horses on 160 acres of golden wetlands prairie west of the Fakahatchee Strand since 1971. Lessor had an idyllic motive for moving to the woods: to bail out of the nervous humdrum of suburban south Florida and cul-

tivate a peaceful lifestyle. But she found everything except peace. She bought her place in January, in the dry season, and when she was ready to build in July, in the wet season, the entire property was under water. Tough and determined, Lessor learned to operate a backhoe and a bulldozer. She dug a pond and used the fill for a home-site and corral. With blocks of limestone caprock dragged from the pond, she built her ranch house. But even with a dry patch to live on, she wasn't out of the swamp. Horseflies descended in swarms, gorging on Lessor's Arab mares and pinto stallions, draining their blood to the point of anemia. To save the horses, she had to keep them in their stalls during the day and let them run in the corral only at night. Then the mud daubers invaded. The tiny insects didn't bite or demand blood, but they nested in every crack and opening, building mounds from Everglades muck that hardened into concrete balls. They built their nests in screens, on walls, in cabinets and drawers. One day, her truck wouldn't start. When Lessor popped open the hood, she found the mud daubers nested in her carburetor.

Every season brought a new struggle against the elements. The elements always won. One day a bellyful of Florida holly poisoned her nanny goat, leaving three newborn kids to be fed; another day, a cottonmouth caught her billy goat in the neck. Higher predatory forms visited next. Bobcats took more than twenty-five geese, but a rarer, more fearsome intruder collected his share, too. He was sighted only once—by a hired hand cutting grass near the pond, who came running breathlessly to the kitchen door, stuttering, "P-p-panther!" The panther had dragged a goose into the brush by the time Lessor reached the backyard. Lessor climbed on a shed roof, eager for a glimpse, and fired her shotgun twice into the air, hoping to flush him out. But she could see nothing. So, bravely, but not too bravely, she started a gas-powered weed cutter and crept into the bush, picking up a trail of feathers and tracking them to the crotch of a tree, where she found the goose, head and shoulders ripped off.

Lessor heard the panther's scream far off. Figuring the panther was angry that she had his prey, she went back to her wash. Soon, she heard the panther's screams draw closer again, until he returned to the crotch of the tree and retrieved the bird. It was Lessor's last goose, ever. Chickens were easier to pen.

Lessor, like most white swamp dwellers, fought the swamp as an alien environment, hostile to the life she sought to create. But on subsequent visits to Orchid Isles, Clyde and Niki discovered that for the Indian neighbors, who had made peace with the swamp generations earlier, when they had been chased there by American soldiers, the conflict was not against the nature of the place but against the people who had altered it.

The Indian couple who lived across the trail from Orchid Isles, a young mother of the Bird Clan, Cassandra Osceola, and her husband, Henehayo, looked more like harried parents amid their brood of five children than combatants of white intruders. When they met the Butchers, they discovered they shared the same dream. Henehayo was an artist like Clyde. He painted scenes of Indian life and hoped to build a gallery of his own just a few miles east of Orchid Isles. But to do that, he would have to do what his grandparents and great-grandparents had tried a century earlier: defeat the federal government.

Henehayo had lived near Orchid Isles all his life, making his livelihood logging cypress to build thatched-roof chickee huts beside Miami swimming pools. His business catered to a modern world, but his family abided by a traditional one. They spent evenings in the open air under a communal chickee, cooking meals on great iron skillets over four flaming cypress logs arranged in a cross, as other Miccosukee had done for hundreds of years. They slept under palm thatch. They spoke to their children in the Mikasuki tongue, even though the children learned English in public school. They named their oldest son Chonoulalthe, which means "to preserve." And

Henehayo himself was the protector of his clan's sacred medicine bundle—a deerskin cache of dried herbs, minerals, powders, snake fangs, and bones—which constitutes the clan's spiritual essence. Each spring, he carried it to the clan's Corn Dance, a ceremony of cleansing and renewal, dating back, the Miccosukee say, to the dawn of time, when the Breathmaker gave them life.

But Henehayo and Cassandra hadn't a true home of their own. They lived in a camp of the Otter Clan, the clan of his mother, where they technically did not belong. The Miccosukee matrilineal clan system dictated that they should live with Cassandra's Bird Clan; husbands always followed their wives after marriage. But Cassandra had no camp of her own. Her mother and sisters had been persuaded to abandon their family homesite and move to a federal reservation.

Henehayo told Clyde and Niki that reservations are prisons without bars. He reminded them that the Miccosukee never signed a surrender to the United States, frustrating the army's thirty-year effort to eliminate all Indians from the Florida peninsula. Other Miccosukee saw the reservation as a necessary evil, a last chance of survival. But by shunning the reservation, Henehayo upheld a Miccosukee tradition of independence: Every man is his own leader.

When Henehayo met the Butchers, he realized that he and Clyde had a lot in common. They both could do nothing else but follow their own dreams. Just as Clyde could never manage to work for a big architecture firm, Henehayo wanted no tribal board to tell him how to think. So his solution to his family's homelessness was simply to mark off a plot in the Big Cypress Swamp and build a home and gallery. But he couldn't do that without the permission of the Department of the Interior and the National Park Service, whose authority he didn't even recognize. Clyde, who was awaiting the

closing of the Orchid Isles sale, anticipated similar obstacles when he tried to build, but at least he would have legal title. The Osceolas were stuck. They had no means—financial or legal—to take on the federal government.

The Osceolas questioned whether their family could live traditionally much longer. Reservation authorities offered thousands of dollars in membership dividends to independent clans like theirs who would abandon the camps and join them. Those enticements multiplied as the tribe expanded its activities to high-stakes bingo and laid plans for casino gambling. The National Park Service promised the family that they would not be evicted from their existing camps in the Big Cypress. But they would never hold title.

Henehayo regarded Clyde and Niki with more irony than envy. The messages of Clyde's photographs and Henehayo's paintings were nearly alike—a celebration of natural values. But Henehayo

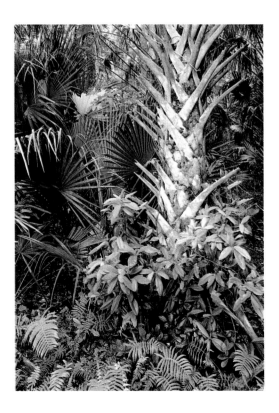

feared that they had met just in passing: one artist entering a bright future, while the other vanished into a genocidal past.

But Clyde and Niki weren't so confident of a bright future. They wandered the subtropical paths of Orchid Isles, debating. They felt on the brink of another gamble with their lives, only this one was linked to their memory of Ted, so they dearly wanted it to work. Leon Whilden was ready to sell it all to them, the eleven acres, the shacks, even the thousands of precious orchids, untended and growing wild, and they were nearly ready to buy. By bringing Clyde back to Orchid Isles, Niki knew she had taken an almost irrevocable step. She had learned in their marriage not to confront her husband with a dream unless she absolutely believed in it. Because Clyde would force her to live it. Now they had to decide. Clyde and Niki looked up, through the towering cypress, at the high green canopy, and down at the riot of blossoms. They decided yes.

Days later by the pond, while waiting in the car for Clyde, who was offering Bill Akers a job as Orchid Isles's caretaker if he promised not to drink, Niki found the reassurance she wanted. Sitting in the heat, she was bored, frustrated that she had nothing with her to read. She began thinking of her childhood when, on long trips, she and her mother would entertain themselves by finding letters in roadside signs, trying to be the first to construct an alphabet. As she remembered, her eyes focused on a power pole near the car. On it was a small surveyor's code stamped in metal. The marks were old, and she could barely make them out. Numbers and a letter. T11786. Her whole body felt electrified. The pole, the whole property, couldn't have spoken more clearly to her if it had used a booming voice from the sky. T1 was for "Ted," her one son. Seventeen was how old he was when he died. Eighty-six was the year of the accident.

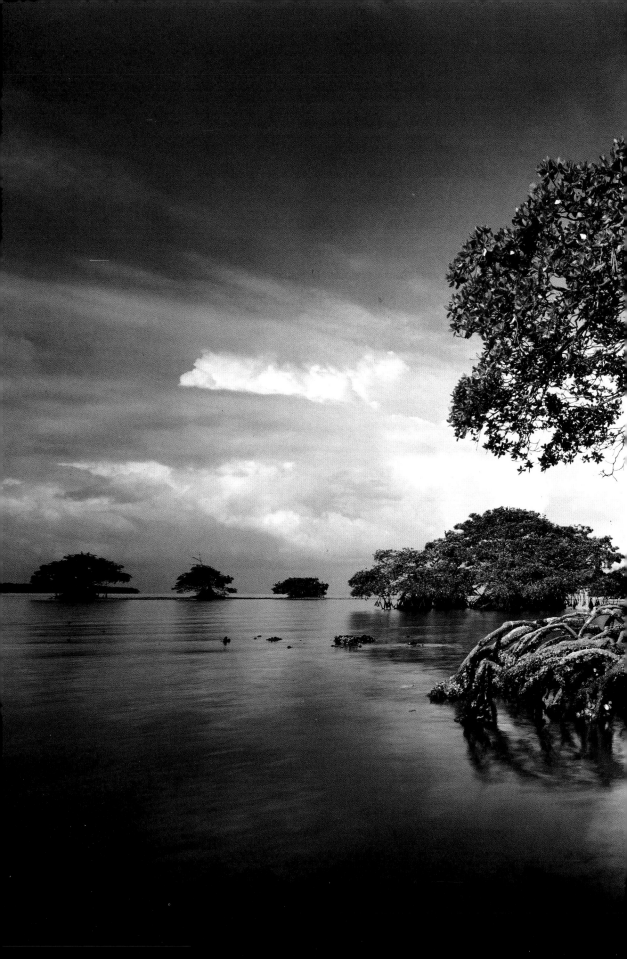

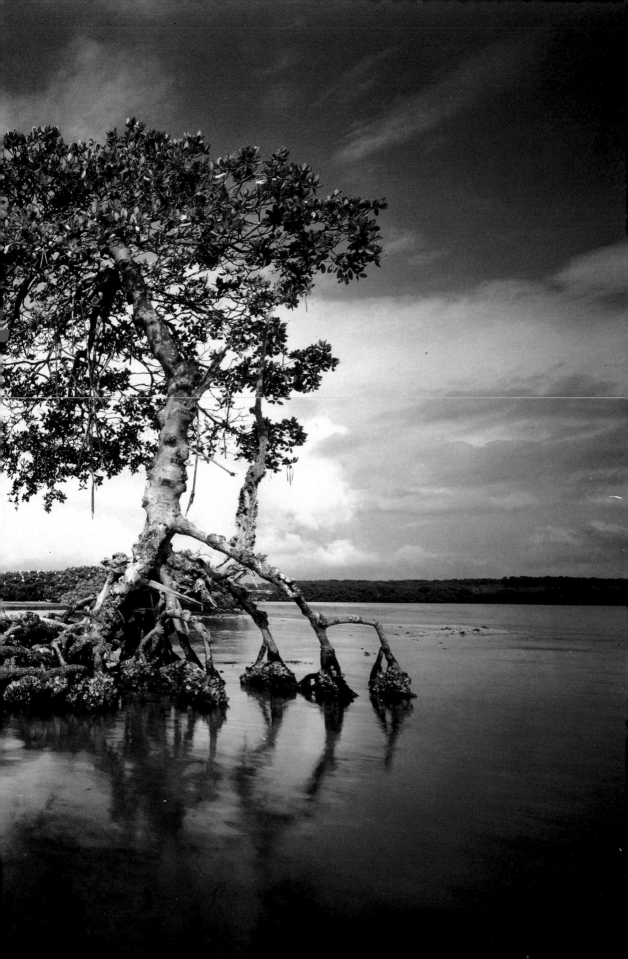

10. *The Music of Angels*

If you sketched the two thousand square miles of remaining wilderness at Florida's tip, it would be a rough square outlined in blue—the Gulf of Mexico on the west, the Atlantic to the east, Lake Okeechobee to the north, and Florida Bay on the south. Put a dot in the exact middle. That's where Clyde and Niki would build their new home, where Big Cypress butted up against the main flow of the Everglades, fifty miles from anywhere. The closest suburban supermarket is an hour and a half away. Completing any project, however simple, is a logistical challenge. Unclog a drain? First persuade a plumber to make a three-hour round-trip house call. Build a house and a photo gallery on raw land in the middle of a swamp?

For some reason, the Butchers thought they could have everything up and running in six months. Part of that extraordinary optimism owed to Clyde's usual full-speed-ahead, damn-the-torpedoes

style. But part of it came from the almost magical sequence of unlikely events that had brought them this far. It should have been impossible to find this property for a price they could afford. And once they found it, it should have been all but impossible to build a new home and an art gallery there. The federal government had been trying to move people out of the Big Cypress for years. It had allowed a few old-timers to stay, but only on the grounds that they not build any additions. Anyone proposing to start up a completely new enterprise should have created a bureaucratic maze that would have daunted Ulysses. Clyde seemed exempt. When he walked into the Collier County planning office, the chief planner had Clyde's "Save Our Rivers" poster hanging behind his desk. Clyde's next stop was the Big Cypress Preserve headquarters. There the chief ranger had Clyde's "River of Grass" picture on the wall.

Clyde was playing to a highly appreciative audience. The approvals sailed through. Clyde was the front man, but Niki was at least as motivated to move into the swamp as he was. In the vacuum following Ted's death, Clyde had found his vision, his commitment to express the swamp in black-and-white. Niki, who had been busy attending the needs of husband and daughter, had neglected her own.

As the weeks and months went by, Niki's grief refused to show signs of healing. She drifted from art festival to art festival by rote, the familiar routine a sedative. She went through the motions, watching the crowds flow by her as if from a great distance, curious that people could go from place to place absorbed in the moment, as if nothing would ever change and nobody ever die. She marveled that she had once been like these people, able to casually participate in life. She didn't know how she could ever manage to feel easy again.

One afternoon Niki had her own epiphany. A man wheeled into their booth in a wheelchair. One leg was gone, chopped off above the

knee. She watched the man look through Clyde's photographs, chat with Clyde, then go on to the next booth, just like anyone else. Suddenly it struck her that she and that man were the same. He had lost a part of himself, and so had she. It would never grow back. She would never be whole. But she could get on with things.

Building the home and gallery in the Big Cypress was the way Niki was getting on with things. She thought of the whole massive undertaking as their "project," as if the final product would be a work of art in itself.

And as all artists must, she and Clyde would suffer in the creation. After their auspicious beginnings, their project bogged down. To begin with, Leon the hermit had left Orchid Isles submerged in litter. During decades of planting exotic flowers, he had never removed a single plastic flowerpot. The cypress trees were nearly as thick with his discarded junk as they were with vines and flowers. Just as the Butchers finished cleaning up, the most destructive hurricane in American history, Andrew, smashed its way through the swamp, turning the freshly cleared property into a scrap heap. A handful of the giant old-growth cypress, some possibly hundreds of years old, toppled. But most stood their ground, sacrificing lower branches to the buzz-saw winds, and contributing to the mess below. Between the expense of building a water-treatment system from scratch, which cost thousands more than they had anticipated, and the double clearing of the land, the Butchers quickly ran out of their construction funds and had to borrow from whatever sources they could find, including running up a $20,000 debt on a handful of credit cards.

But Hurricane Andrew did more than topple some trees and strip a thousand limbs; it made the already daunting task of finding contractors and building supplies and bringing them to the middle of nowhere a virtual impossibility. The Butchers had no choice but to

rely on Bill, the itinerant, temporarily reformed drunk they had liberated from servitude to Leon Whilden, and a man who showed up on their doorstep in a jury-rigged trailer containing his wife and all his worldly possessions, claiming to be a licensed contractor temporarily down on his luck. With this salvage workforce, the gallery went up, a low rectangle with a peaked roof that fronted on the highway and opened onto a small porch overlooking a paradise of exotic blossoms—flowering air plants and orchids—perched on the gnarled and mossy cypress. A stream of clear water flowed from the back of the gallery along the bank of the fill island stretching a few hundred feet into the woods to the clearing where Leon had built his shack.

The Butchers would build their new home there, on the precise lines of the shack's original foundation, just as the gallery had been built on the foundation of Leon's orchid house. The Butchers had no choice in this. No part of the Big Cypress could be covered with a manmade structure if one had not been there to begin with. The plans for their house called for a modest two-story box, with a darkroom and studio on the ground floor and a small two-bedroom apartment on the top. The only departure from the purely utilitarian was a wide second-story porch overlooking a small dock where the deep water wrapped around the island, flowing at the feet of the biggest and oldest trees. The house site and the gallery were connected by a narrow dirt trail through the cypress. Once the gallery opened, the braver visitors would inch their way tentatively down the path, curious where it might lead. But most were too scared of snakes and alligators to stray far from the gallery porch. Some were tourists, many from Germany and England, who drove out the Tamiami Trail wanting to see the Everglades, stopping at Frog City, Buffalo Tiger's airboat rides, and the Miccosukee Indian Village and Culture Center before noticing the Big Cypress Gallery sign and stopping yet again, another roadside attraction. But increasingly, people came out there, fifty miles from the cities on either coast, for no other reason than to

see Clyde's pictures, and maybe catch a glimpse of the man himself. The cash from sales at the gallery, and the ever-growing sales at Florida art festivals, began to staunch the financial hemorrhaging. And slowly, very slowly, the home began to rise in the swamp.

Then Bill fell off the wagon and drank too heavily to be much use; their live-in contractor absconded in the night, making off with the washer and dryer, and leaving behind shoddy workmanship: roof beams left unsecured and air conditioners installed upside down. Inspectors threw their hands up in disgust.

Meanwhile, Clyde and Niki were living out of boxes in their Fort Myers studio, commuting the two hours to the Big Cypress, where they entertained tourists at the gallery and tried to inch their home toward completion. For a time they had slept in a makeshift bedroom on the bottom floor of their unfinished home, in the middle of a construction site. When the building inspector chased them out, they were once again essentially homeless. Six months stretched into two years. There was a time when the interminable delays, the endless improvisation of even the most mundane details of life, might have nudged Niki over the edge, but she was different now. When they had lost their company, she consoled herself with the knowledge that they had at least been able to come out of it with a measure of financial security. When the annuity had vaporized and they were plunged into bankruptcy, she learned that the only thing she really needed was her family. And then she lost the one thing she was sure she couldn't survive losing. Now an upside-down air conditioner, a disappearing contractor, and a never-ending construction project did not strike her as devastating problems.

When Jackie came to her mother with the news that she was pregnant, but unattached to the father, Niki was worried. Not about Jackie, but about Clyde.

Jackie was doing fine now. She'd worked through the grief for her brother and emerged into a dynamic adulthood, following in her

125

father's footsteps by creating her own business, manufacturing and marketing art postcards and sportswear. But for all her accomplishments and aggressiveness, she couldn't bring herself to tell her father she was pregnant and determined to raise her child alone. She asked Niki to break the news.

Niki approached Clyde warily, told him to sit down and brace himself. "There's something you need to know about Jackie," she said. Clyde's face turned ashen. He sank into a chair, ready for the worst. "Jackie's pregnant."

Clyde looked at Niki blankly—confused. "What else?" he said finally. "Well, that's it," Niki replied.

Clyde nearly laughed with relief. *Pregnant?* What was the problem with that? "Life is every way better than death," he said.

She and Clyde were once again on the same wavelength. They knew what real devastation was. Anything less than devastation was simply another part of the puzzle. For every negative, there was a positive. Niki believed that deeply, and she believed that if she didn't practice that belief, she would end up a bitter person with a shriveled soul. So she counted her blessings as if each were a bead on a rosary.

True, Bill had gotten drunk and made threats and been a problem, but before he self-destructed he had lived in a trailer in the wilderness and kept an eye on the place when no other eyes were available. Even if some of the disappearing contractor's work on the house had to be torn out and done over, he had still managed to move construction along at a time when every other contractor in south Florida was busy in the hurricane rebuilding. On the day Clyde arrived at the site to find a damp, dark spot where the trailer had been and bare pipes sticking out from wall space only recently covered by a washer-dryer, two men appeared to give a bid on installing the drywall. Clyde said, "What else do you do?"

"Everything," the men responded. The first thing they did was rip out and repair all the sloppy work of their predecessor. And then they pressed on. Once again, the dream seemed attainable.

One morning Niki drove the empty road through the Big Cypress, alligators sunning on the banks of the canals on either side, flowers waving in the wind, feathery cypress branches swaying. Suddenly, the light seemed to go brighter, as if a cloud had passed, or a dark lens been lifted from her eyes. Her heart rose up in her chest as if it were inflating with helium. She had no choice but to pull the car onto the grass at the side of the road and sit there, overcome with a joy so intense, so unexpected, tears streamed down her cheeks. It was as if luxurious feeling had suddenly flooded a limb long paralyzed. She felt the breeze with its rich scent of sap and spore, rot and riotous growth. She watched as every branch, every leaf of the multifarious jungle that surrounded her for miles in all directions moved together in the wind. It was as if the wilderness danced to sublime music she could feel but not hear — the music of angels, she thought.

Clyde heard that music, too. Sometimes he'd be standing in a small clearing on his personal island in the vast flow of the Everglades, the hammers and saws silent for a moment, and all the calculations of cash needed and construction undone would drop into the subtle whirring life that engulfed him: the shockingly graceful arc of an orchid rising from the mossy crook of a low cypress branch; the stunning intrusion, through a blue hole in the tree canopy, of a pair of Everglades' kites, streamlined creatures that looked as if they had been designed by Chinese artisans. White heads and chests sweeping to black wingtips and shocking V-shaped tails, they shot through the treetops, floated directly overhead, then soared away on a thermal, a crescendo in the symphony.

Only now, whenever Clyde heard the music, he could not screen out the minor key creeping in.

Soon they would be settled in the house. He would have his gallery space and his darkroom. Niki would have some gallery space of her own and a studio filled with the light that streamed through the cypress. In the evening they could sit on the upstairs porch over-looking the back strand and stare into the mysterious heart of the Big Cypress until the dark rose up from currents pushing south through leagues of wilderness to the southern seas. Their little corner of the world was protected — for now — from the multiple traumas that were killing what was all around them. The luck of waterflow and isolation from development had left their corner of the wilderness as pristine a stretch of Everglades as existed anywhere. Clyde could probably spend years taking pictures within slogging distance of his back porch. But he could no longer purely enjoy the peace and beauty of the place. Everything was tainted by mortality, a sense that what exists now cannot last, that all the things that have made the Ever-glades eternal have been subverted, perverted, mutilated, or poisoned.

The response to Clyde's work had made him more than a bystander. As his photography gained attention, his connections multiplied. Scientists who had spent their professional lives delving into the mysteries of the Everglades sought him out. Politicians and ecologists looked to him to support their causes. Clyde soaked in what each had to offer. He grounded himself in the debates on obscure points of microbiology, hydrology, and engineering upon which the future of the Everglades depended. He immersed himself in the intricate legal wranglings and political posturing that in the end would determine who would pay and who would profit, how much of the swamp would be saved and how much sacrificed. It was a quick education, though not an easy or pleasant one.

What seemed so obvious to Clyde — the importance of wilderness, of our spiritual and physical need for its regenerative power —

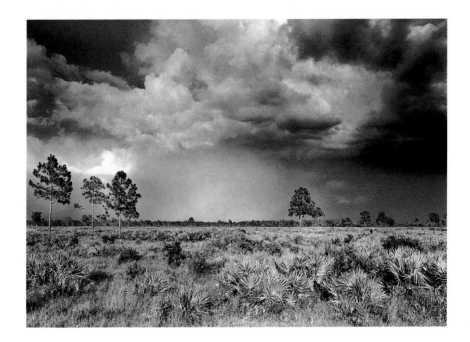

was being acknowledged by all. In public. In private, that truth was sacrificed and sabotaged time and again in the conviction that nobody really understood, or cared.

Clyde was not inclined to embrace the quick solutions that are so often appealing to people in the throes of political struggle. He knew that oftentimes solutions were complicated, problems intractable. When he heard the more extreme conservationists fume, he scratched his beard and shook his head. He did not believe that the wilderness should be saved by evacuating Florida, or even banishing the sugar farmers who had grown rich on the corpse of the Everglades. He knew intuitively that the only meaningful solution was to find a way for men and swamps to coexist. This was a people-heavy world, and if the future was going to have wilderness in it, the wilderness would have to survive close encounters with human beings. If you were going to outlaw farms, as some advocated, the next step was to outlaw the babies farmers fed.

Besides, the farms in the Everglades were phasing themselves out. With each season, the sugar companies dug their own grave a lit-

tle deeper, wearing away the deposits of Everglades muck inch by inch. Already their fields were feet below the elevation of the saw grass prairies to the south. In three generations, the sugar farmers had burned through soil that had taken thousands of years to form. How much longer the fields could continue to produce crops was a debatable question, but what was certain was that the sugar fields could never be restored to their natural condition. What had been a vast, shallow sheet of living water could only be made over into an immense moribund lake, a water-filled quarry pit.

It was easy to think there was no hope. Clyde had even seen predictions that global warming might elevate sea level by eleven feet in the next century. If that proved true, then the whole question of saving the Everglades would be moot: There would *be* no Everglades. The sea would drown them, leaving once again a shallow ocean reef, five thousand years of life transformed into one more thin layer of sediment in the geologic structure.

But Clyde couldn't think like that for long. He had to take it one threat at a time, and clearly the most immediate was the phosphorous runoff from the sugar farms that was poisoning the remaining wilderness from the top down. Unchecked, phosphorous pollution could kill the Everglades within a few generations. But Clyde's scientist friends had an ingenious solution. And, given the obvious connection between the health of the Everglades and the preservation of two things Florida can't do without—clean water and a tourist-luring environment—it was a hell of a bargain. The salvation of the swamp could be brought off for roughly twice the cost of a single space-shuttle mission.

Two shuttle launches? Or a living Everglades for our great-grandchildren? It infuriated Clyde to think that as shuttles blasted into the sky one after another, their windblown contrails visible on the Everglades horizon, a privileged few were doing all within their

considerable power to keep the wilderness restoration project from ever getting off the ground.

The plan for restoration was exquisitely simple, and began with a simple observation: Though the agricultural area had been draining phosphorous runoff into the Everglades for decades, you didn't have to go very far downstream before the water was entirely pristine, as pure as rainwater on a mountain peak. Forget sewage treatment plants. Forget fancy engineering and vats of chemicals. The marsh plants themselves cleaned the water, drawing out the phosphorous with astonishing efficiency, as if the element, once rare in the Everglades, was still a boon instead of a choking burden. But the eager marshes filled up quickly. Any given section of marsh could not clean up after the farmers indefinitely. Not without help. That was what the restoration project was all about. Giant dikes would be built around marshland at the southern edge of the sugar farms to segregate the dirty water from the clean. When the marsh plants in the diked treatment areas had drawn up all the pollution they could hold, they could be harvested, replacements planted, and the cycle of cleansing begun again.

Building and managing these areas would not be cheap—that's where the NASA-type budget came in. But there was an obvious source for that money, or much of it: the fabulously wealthy sugar farmers who had caused the problem to begin with.

For twenty years, it had been illegal to discharge dirty water into the Everglades. For twenty years, Florida's government had turned the other way while the sugar companies did just that.

In 1988, just as Clyde was beginning to understand the wilderness was dying, the U.S. Justice Department sued Florida to force the state to enforce its own law. To Clyde, it seemed as if the calvary had thundered over the horizon. But his elation was premature, if not altogether misplaced. The state government responded to the federal

challenge by spending millions of taxpayers' dollars—not to solve the problem, but to fight the suit. The sugar companies themselves added millions more to the war chest, and bought scientists and engineers to argue their case: The farms weren't really polluting. Well, maybe they *were* polluting, but the pollution wasn't doing any damage. Or if it *was* doing damage, it wasn't the farmers' fault.

Even Clyde could see that the research was based on faulty premises and strained logic. But if the effort to derail the federal suit couldn't stand up to much scrutiny, it succeeded in wasting enormous amounts of time and resources that were stretched thin to begin with. The sugar growers had plenty of money, and all the time in the world.

Five years went by, and each year, more of the remaining Everglades were lost. Finally weary of the battle, the feds backed away, giving the state another chance to solve the problem in its own way. A law was quickly hammered out. One of its most notable features: It made sugar growers exempt from the restrictions against pumping waste off their farms. In return for this largesse, the sugar growers agreed to help pay for the treatment areas, but only some of what would be needed, and only if it were proven that was the best and cheapest way to treat the farm runoff.

And if the money ran short, or the costs inflated, well, maybe the whole project would be dropped. There was nothing in the new law that guaranteed the job would get done.

Clyde noted with bitter irony that the governor had named the state law that accomplished all this after Marjory Stoneman Douglas. Douglas was pushing 104, but she wasn't comatose. She saw the law as a deal with the devil, and she insisted she wanted her name off the bill.

Clyde went through periods of near-despair. He saw the swamps and marshes degrading before his eyes. And he knew that the people who didn't care had time on their side. If they stalled,

sued, argued long enough, there wouldn't be anything left to save. If the politicians simply declared victory and walked away from the mess, who would know? Who could understand the complexities of this immense, watery place? Who really wanted to make the sacrifices it would take to save it?

Clyde knew it wasn't just the sugar growers, or the politicians. It was people who wanted to believe that all they had to do to save the planet was throw some aluminum cans in a recycling bin. It was people who wanted to run their air-conditioning from March through November and water their dry season–parched lawns from November to June. It was people, Clyde knew, like himself, who wanted to live in the middle of the wilderness and drive fifty miles for a jar of pickles. In his dark moments, Clyde entertained the notion that his own peculiar race must be of extraterrestrial origin. How else to explain that every tendency seemed to run contrary to the best interests of the planet it inhabited?

Just as Clyde's mind once compulsively designed better closets, it now grappled with the designs of a better world. The problems were daunting, but there were a thousand ways, both small and large, they could be attacked. At any given time, Clyde mulled over a catalog of wasted opportunities: If the billions spent building soulless suburbs on paved-over swamp had been spent instead on rebuilding the inner cities, south Florida might be a thriving metropolis surrounded by beautiful wilderness. Instead, it was crime-haunted, on the verge of ecological collapse. If people could simply add the cost of solar panels and home water-treatment plants onto their tax-deductible home mortgages, energy and water problems would diminish overnight, and the economy would enjoy a boom of constructive construction.

There were a million things that *could* help. But they wouldn't happen, Clyde knew. Not until we were willing to make small sacri-

fices, things like not flinching at the idea of showering in perfectly clean water that yesterday had been sewage, or paying a little today to avoid paying more later. Not until we could open our eyes and see what we so blithely destroyed. Not until we changed.

But you can't teach change, or preach it. People had to be shown. In black-and-white. Forgive Clyde Butcher for thinking he might have a hand in that.

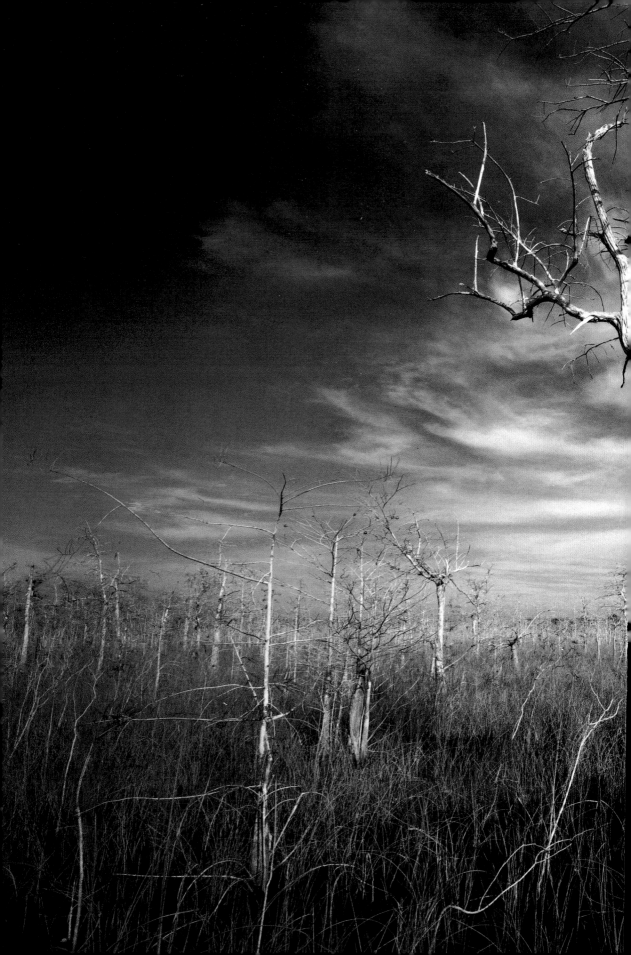

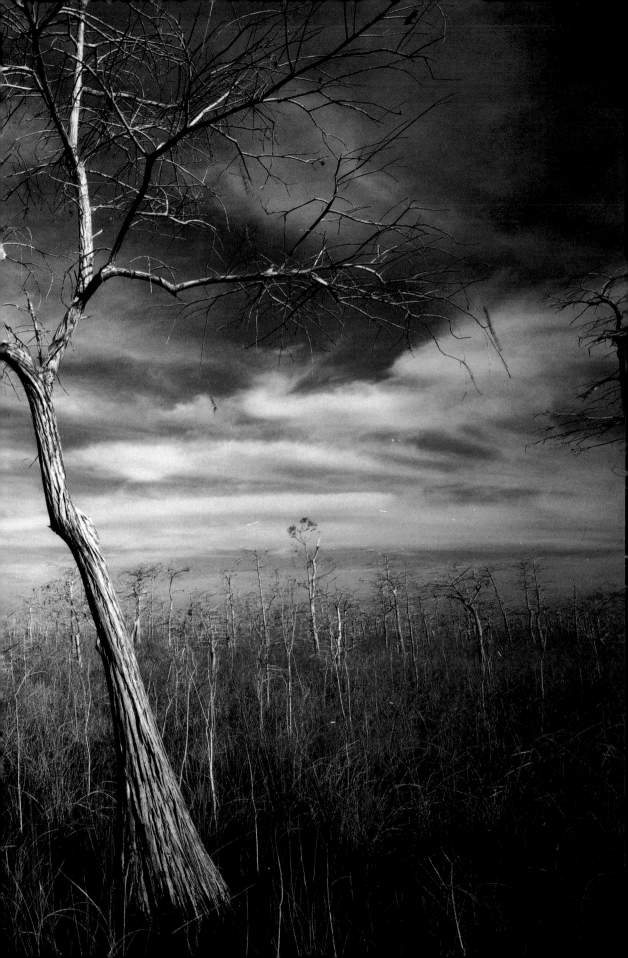

11. Homecoming

The construction of the Butchers' Big Cypress sanctuary adjourned one morning when Oscar Thompson arrived at the gallery laden with cameras, blankets, mosquito net, tarp, a loaf of bread, a jar of coffee, and two cans of lima beans. Clyde required no further prompting to lay down a carpenter's belt and sweep the cypress needles off his swamp buggy. His own contribution to the supplies were eighty pounds of camera gear, a case of very warm Diet Pepsi, two cans of Beanee Weenees, and two quart jars—one filled with dill pickles, the other with peanut butter. Such stores were considered sufficient for two days of sustenance, supplemented, if necessary, with fruit of the swamp: coco plums, pond apples, and tamarind.

They had no sooner plunged the buggy over the edge of a limestone road into a shallow pond when the engine choked and died. It took Oscar a half hour of wriggling under the chassis with his penknife before he solved the problem: water in the fuel line.

Water everywhere. A storm engulfed them an hour later. They shut off the engine and sat in the middle of a wet prairie listening to the rain pelt the blue tarp above their heads, eating peanut-butter-and-pickle sandwiches.

When the rain let up, it was already late. The water was high from a wet summer; dry ground was hard to come by. Under usual conditions, it would have been sufficient simply to head the buggy toward any aggregation of pine trees to find an elevated patch of dry ground called a pine island. They checked half a dozen, all at least six inches under water. They ended up camping on a tiny square of half-wet muck, discovered at the center of a particularly thickly forested pine island just as darkness fell.

It rained all night. Rivers of runoff dripped from the edge of the tarp they had strung for a roof and cut trenches beside their sleeping bags. Clyde snored like an airboat roaring through the night. At least the sun rose. They let it rise a bit to dry their gear, then loaded up and followed an old buggy trail north, stopping here and there to take pictures. By mid-afternoon, the trail curved through three feet of water, then rose onto a broad oak hammock, between Windmill Prairie and Raccoon Point, not far from the Miccosukee's sacred Green Corn Dance grounds. The island had long served as a hunting camp. The ground was littered with shell casings, broken pack straps, charred kindling, and the remains of a hog's jaw, picked clean. Deeper in the soil may have lain the charred remnants of Miccosukee campfires from a century ago, or even those of Calusas, who lived on these islands until they were virtually wiped out by Spanish soldiers and European disease.

Oscar kindled a sizzling, spitting fire from pine knots and retrieved a pot of water from the inundated prairie. He heated the water for coffee. He then discovered that neither he nor Clyde had remembered silverware. He grumbled briefly about the poor provi-

sioning, then stopped. "Damn, I ain't helpless out here," he scolded himself. He cut a young green frond from a palmetto with his pocketknife, then carved away all but the center cup of the spreading leaf. He had fashioned a crude but effective spoon, with a stiff throat and a slightly concave bowl, whose edges were firm enough for cutting. "Indian style," Oscar said.

Over the fire, the men talked about Oscar's childhood friend Billy, who, among the last of the Everglades' dwindling band of hermits, lived in solitude on an island not far from their campsite. Nine years earlier, in the dry part of a drought year, Oscar had literally worn a path to the camp by going in and out in a four-wheel-drive truck tricked up with chains and loaded down with building supplies. With help from Billy, he'd built a new cabin on the ashes of one Billy's father had built years before. Not long after that, Billy moved to the cabin. He'd had it with normal society, and except for brief trips out to visit his mother and get supplies, he never left the swamp.

But just a few weeks before this trip with Clyde, Oscar had to go in to get Billy. Billy's mother was dying, and not even Billy's own sons could find him. One had spent the better part of a day slogging fruitlessly through the Big Cypress, barely making it back to call Oscar for help. It was late, and raining. Oscar scaled a fifteen-foot barbwire fence along Alligator Alley and hiked five miles, mostly in the dark, navigating by the direction of the wind. At one point, the unmistakable stench of alligator musk froze him. But the gator, who must have forgiven the intruder for his poaching days, fled rather than attacked.

Oscar hit the island, a few hundred square feet of dry land in the middle of a cypress strand, more than three hours after sunset and called through the screen door. He woke Billy up. Billy took one look at Oscar, drenched and muddy, and said, "It must be bad." Oscar didn't even stamp his feet before they headed back into the swamp.

They got to Immokalee in time. Billy's mother died two days later. Billy stayed around a few days to take care of details, then returned to his self-imposed exile. When Oscar walked in to check on him a few days before his trip with Clyde, Billy was nowhere to be found. The calendar taped to the wall of his cabin was still turned to the previous month. After early notations like "saw panther" and "had deer," Billy had written a single word, underlined three times, on the day his mother had died: "loss."

Listening to Oscar talk about his old friend, it was easy for Clyde to see that part of Oscar envied the solitary life Billy led. At any rate, it was certain Oscar would prefer exile from civilization to exile from the swamp. On this dark night, the jungle canopy flickering with reflected firelight, miles from anything human, Oscar was supremely at home.

And now, at last, so was Clyde. He spooned down the last of the Beanee Weenees, then sat on a mahogany log and stared expectantly into the flames.

Somewhere on the washed green prairie the next day, Clyde would find a picture. He and Oscar would break camp and start off in their heaving, slow-geared buggy, and somewhere amid the endless possibilities of the Big Cypress they would find the confluence of life and light that Clyde sought. He knew for certain they would find it.

The owls gave way to whippoorwills before dawn. Then the crows convened in raucous debate. The big airplane tires of the buggy churned into the swamp before the sun rose above the trees. It was early, they had plenty of gas, enough food, and all the water they needed flowing under their feet. Today they would range as far as they wanted. Oscar suggested they head north and west, into some beautiful country he knew over toward Fakahatchee Strand. Clyde steered the buggy up the path and headed out, away from the island. For fifty feet.

He abruptly pushed in the clutch and coasted to a halt in deep water. Just off the edge of the trail stood a small dwarf cypress in a field of dwarf trees just beginning to catch the early sun.

He stared at it, the buggy rumbling eagerly beneath him. It was a runt of a tree, and in its sparse branches grew a single bromeliad. Oscar showed no surprise at the abrupt halt. He began to unstow his gear. Dwarf cypress always did that to Clyde. They were a mystery to him, a perpetual enchantment. A dwarf cypress, no more than six feet tall, might be a hundred years old. Only its base belied the age, thick and elaborately twisted with years, spawning a slender trunk the circumference of a sapling. That was all the growing that the thin layer of muck laid over the hard limestone floor of the swamp would allow. It was the barest of holds on life, but enough for the tree to last a hundred years through fire, flood, and drought. Or longer. Maybe much longer.

"This place feels ancient," Clyde said, nearly to himself. He stared at the odd trees stretching through the still water like a tiny dream forest, then he looked at the sky, wondering when the clouds would come, and how the light would play across the twisted grain of the trunk. He switched off the buggy engine.

Dawn had barely faded into the steady light of morning. They made pictures until dark.

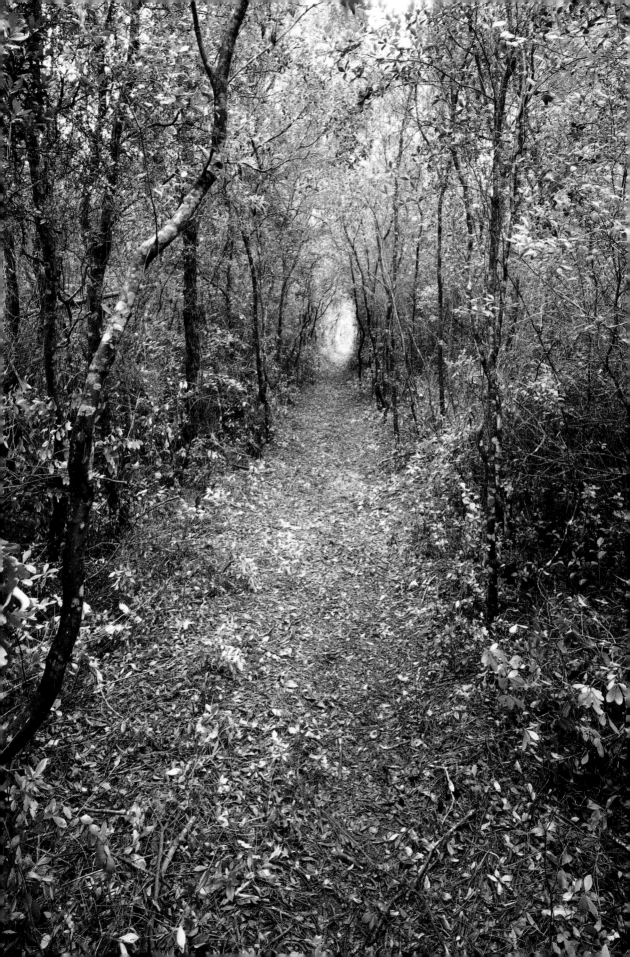

About the Authors

TOM SHRODER is the executive editor of *Tropic*, the Pulitzer Prize–winning Sunday magazine of *The Miami Herald*. He lives in Miami Beach with his wife, Lisa, daughters Jessica and Emily, and son Sam.

JOHN BARRY is a feature writer for *The Miami Herald*. He lives in Miami Beach with his wife, Lynda, and daughter Sarah.

About the Type

This book was set in Cochin, named for Charles Nicolas Cochin the younger, an eighteenth-century French engraver. Mr. Henry Johnson first arranged for the cutting of the Cochin type in America, to be used in *Harper's Bazaar*.

Cochin type is a commendable effort to reproduce the work of the French copperplate engravers of the eighteenth century. Cochin is a versatile and attractive face.